THE COMPLETE
COLOR
HARMONY

GLOUCESTER MASSACHUSETTS

ROCKPORT PUBLISHERS

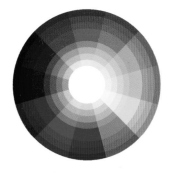

EXPERT COLOR INFORMATION FOR PROFESSIONAL COLOR RESULTS

Tina Sutton and Bride M. Whelan

THE COMPLETE
COLOR
HARMONY

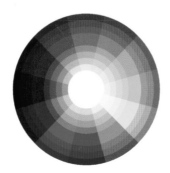

ROCKPORT

First published in the United States of America by
Rockport Publishers, Inc.
33 Commercial Street
Gloucester, Massachusetts 01930-5089
Telephone: (978) 282-9590
Fax: (978) 283-2742
www.rockpub.com

Library of Congress Cataloging-in-Publication
data available

ISBN 1-59253-031-1

10 9 8 7 6 5 4 3 2 1

Cover Design: Moth
Production and Layout: Susan Raymond
Cover Image: Courtesy of Zimmer + Rohde/www.zimmer-rohde.com (top
& bottom)
Courtesy of Glidden, an ICI paint company, www.glidden.com (middle)
Back cover: Courtesy of Mariposa/www.mariposa-gift.com (top right)
Courtesy of Marimekko Oy/www.marimekko.com (bottom left)

Printed in Singapore

Contents

Introduction

When you enter a room, see someone walking toward you on the street, or look up at a billboard while stuck in a traffic jam, the first thing you notice is color. The yellow walls in a child's room make you smile, the red of a woman's coat catches your eye, the orange background of an advertisement grabs your attention.

As Walt Disney so aptly put it, we live in a "wonderful world of color." Color combinations can dazzle, soothe, or charm. In the bird kingdom, a male peacock's stunning plumage of iridescent blues and greens quickens the heartbeat of potential mates. Tiffany's signature blue box can have the same effect on humans.

Colors have such strong associations that even a black-and-white rendering of a brand's logo instantaneously calls specific hues to mind. You don't read Coca-Cola without thinking red, see Wal-Mart's smiley face without picturing yellow, or view an Hermès product without recalling its distinctive burnt orange.

And the more sophisticated the color, the more ownership a brand has. Most high-end customers can't look at a burnt-orange object without thinking of Hermès.

Color is also egalitarian. We can all use and enjoy a wide spectrum of colors in our lives, no matter what our income level or profession. As legendary interior designer David Hicks once said, "Color can achieve more in people's lives than any other element and at the least expense."

It's hard to believe that white was not only the best-selling bedding color at one time, but the only color. In a society that prizes individualism, we now take great joy in choosing color schemes for our sheets, homes, clothes, and cars.

But everyone needs a little help. That's where the experts come in. Consumers of all products are looking for guidance in choosing color palettes that will harmonize with their lives. While many decisions about colors are emotional, based on immediate visceral reactions, coming up with inventive combinations of hues is a more practiced art.

Most people are unaware of the science of color, which starts with the twelve-segment color wheel as a road map to effective combinations. Direct opposites on the wheel are complementary. Adjacent colors clash. Warm colors appear to come forward. Cool colors recede.

Colors also have psychological and physiological effects on our bodies. Reds make people jumpy. Greens calm us down. In a red room, time seems to fly. A pink room effectively lessens anger.

Reactions to colors are so strong that coffee sipped in a blue mug will actually seem cooler than the same liquid served in an orange cup.

We use color every day to inform and sell. Red tells you to stop your car. Silver suggests exclusivity. Spas feature sea greens to reinforce feelings of serenity and antiseptic cleanliness. Sugar companies put blue on their packaging because it connotes sweetness.

Innovative uses of color can open the door to product and market expansion as well. Hair dyes were once directed at a limited market of women of a certain age for covering gray, or as a vehicle for going slightly blonder or darker. Today, teens and men have enormously boosted hair-color sales. The antiquated message of "Does she, or doesn't she?" has been replaced by "Why haven't you?" And not-found-in-nature color effects are a badge of honor, whether subtle or dramatic.

Other new avenues for color development involve chromatherapy and customization. Just as interest in aromatherapy caused an explosion in sales of scented products, chromatherapy presents new opportunities of its own. Ultra Baths, for example, is one of several companies that have installed colored light systems in their tubs. Just touching a button illuminates the interior of the tub in one of seven different colors to cure what ails you. Blue calms, violet stimulates your immune system, and red reportedly helps migraine and rheumatism sufferers.

Similarly, pharmaceutical companies use color to boost product efficacy. There's a reason Prozac is a soothing green and tranquilizers a sleepy blue.

Many chichi boutique hotels already allow guests to customize the color of the lighting in their rooms by flicking a switch. In the near future, we will be able to get whatever color we're in the mood for anywhere at any time.

In many instances, color is the only thing that differentiates products. Why do you buy one wastebasket instead of another, or select a certain toothbrush holder? Sometimes we pick colors that will blend in, other times those that will stand out.

The wrong color can also doom sales. Mass-market bakers in the United States once attempted to sell colored bread, but soon found that consumers were very happy with their crusty brown loaves.

Overall, adults are far more adventurous and sophisticated about choosing color today than they have ever been. The Information Age ushered in by the Internet, along with technological advances in special-effects finishes, has opened a whole new world of color options to even the casual observer.

In paint selection, for instance, customers used to play it safe by choosing the palest tints on paint-chip color strips. Now they gravitate toward the opposite end of the cards, which features more saturated and complex hues.

Women are also making gutsier color choices for their wardrobes. Rather than buying complete outfits

each season, they're opting for items in the latest fashion palettes to update what they already own. Shoes and handbags were once a black, brown, and beige business. Today, the big money is in color—and the wilder, the better.

This book is designed as a guide for anyone interested in the field of color, from graphic, interior, and fashion designers to artists, craftspeople, and flower arrangers. Not only is the science of color explained, but innumerable harmonies are also suggested to fit every mood and end use.

Sections on the psychology of color and color-trend forecasting will be of particular value to advertisers and product designers to aid them in subliminally communicating with target markets.

The days of simply relying on colors that have been successful in the past are long gone. Take advantage of the color harmonies and imaginative variations in this book to launch your own creativity.

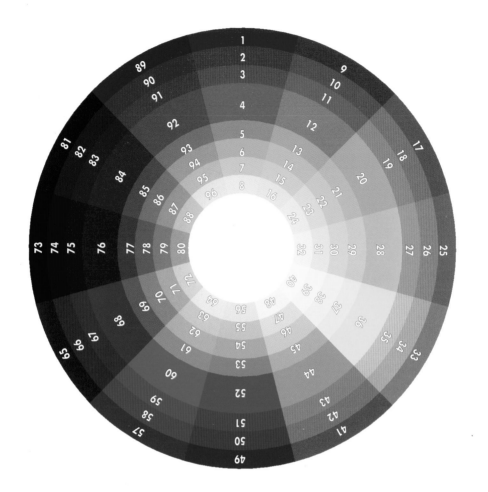

The Color Wheel

The twelve segments of the color wheel consist of primary, secondary, and tertiary hues and their specific tints and shades. With red at the top, the color wheel identifies the three *primary* hues of red, yellow, and blue. These three primary colors form an equilateral triangle within the circle. The three *secondary* hues of orange, violet, and green are located between each primary hue and form another triangle. Red-orange, yellow-orange, yellow-green, blue-green, blue-violet, and red-violet are the six *tertiary* hues. They result from the combination of a primary and a secondary hue.

Constructed in an orderly progression, the color wheel enables the user to visualize the sequence of color balance and harmony.

How to Use Color

Working with color to achieve intended results can be a challenge, but it can also be fun! An effective color scheme can make a room feel warm and inviting, a graphic design able to attract attention, or a poster to recall days gone by. Before learning what colors to use in order to achieve the best results, one must first understand some basic color terms.

Each primary, secondary, and tertiary hue is at a level of full *saturation*, or brightness, which means that there is no black, white, or gray added. Color is described in terms of *value*, which is the lightness or darkness of a color, or the relative amount of white or black in a hue. White added in increments to any of the twelve colors results in lighter values of the hue called *tints*. For example, pink is a tint of the primary color red. The incremental addition of black or gray to a hue results in darker values of the hue known as *shades*. A shade of red is burgundy or maroon. These shades and tints are illustrated by the color chart on the following pages.

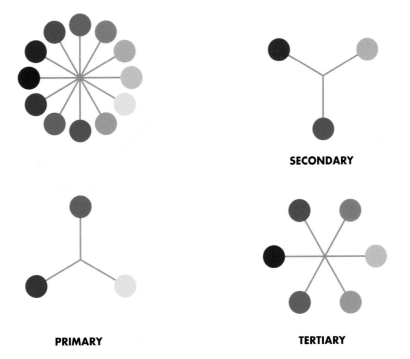

SECONDARY

PRIMARY

TERTIARY

The Color Chart

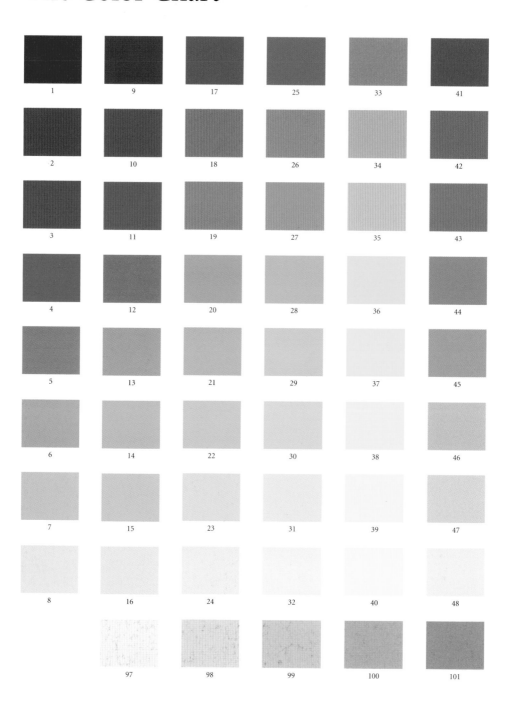

1	9	17	25	33	41
2	10	18	26	34	42
3	11	19	27	35	43
4	12	20	28	36	44
5	13	21	29	37	45
6	14	22	30	38	46
7	15	23	31	39	47
8	16	24	32	40	48
	97	98	99	100	101

The color chart is the color wheel in chart form. The rows above and below the fully saturated center hue represent the tints and shades of each color. Each hue, tint, and shade on the chart below is numbered 1–96 for easy reference. Numbers 97–106 represent the value range from lightest gray to black. These numbers correspond with the colors used in combination throughout the book and offer a wide selection of balanced and effective color possibilities within each interpretive section.

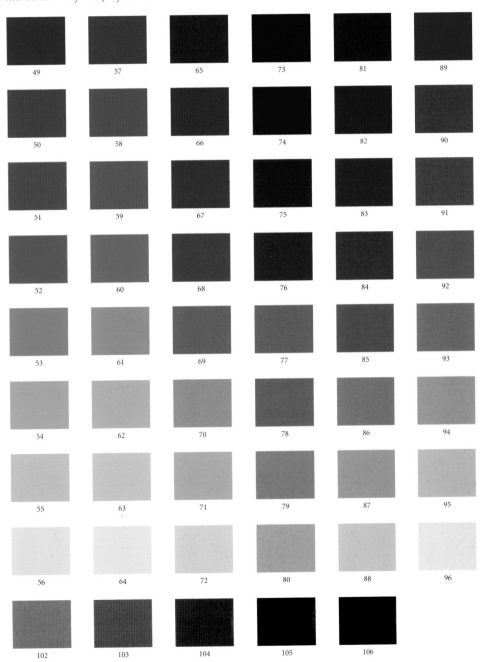

13

The Process

The Complete Color Harmony is divided into sections to show aspects of color and color combinations that visually explain the effect color has on our lives. The color conversion chart and the color wheel, on pages 10–13, and color cards all work together to develop unique color possibilities. *The Complete Color Harmony* explores color terminology, the aspects of color, color schemes, and color combinations. It serves as a practical guide for accurate and positive results when designing with color.

STEP 1

Clearly define the results you want to achieve with color.

STEP 2

Select a main color that reflects the needs of the project.

STEP 3

Select a color scheme based on the choice of the central hue.

STEP 4

Refine the available color choices in terms of the particular project or individual sensibility.

Aspects of Color

The aspects, or qualities of color, refer to colors and color combinations that evoke certain emotional responses. We use many words to describe the properties of individual colors and to compare and contrast them, but *light* and *dark* is the basic distinction. Without sunlight or artificial light, there is no color. We depend on light for color, which we use in countless combinations to express our ideas and emotions.

The following aspects of color contain color combinations that exist in harmony with each other, and are in spectral balance. *Spectral balance* occurs within the eye as thousands of waves of electromagnetic energy of different lengths bounce off (or are absorbed by) the chemical components of any object. Light waves reflect red, yellow, and blue, and the rods and cones in the eye's retina simultaneously mix and sort these reflected colors into thousands of tints and shades, which work to offer endless possibilities for specific color use.

Color is both simple and complex. It means different things to different people in different cultures. No color is seen the same way by any two people. Color is personal and universal, sending messages full of endless variations.

Hot

Hot refers to red in full saturation on the color wheel; this is red at its strongest.

Hot colors project outward and attract attention. For this reason, red is often used in graphic signage and design.

Hot colors are strong and aggressive and seem to vibrate within their own space. The power of hot colors affects people in many ways, such as increasing blood pressure and stimulating the nervous system.

Cold

Cold refers to fully saturated blue. At its brightest it is dominating and strong.

Cold colors remind one of ice and snow. The feelings generated by cold colors—blue, green, and blue-green—are the direct opposite of those generated by hot colors; cold blue slows the metabolism and increases one's sense of calm. When placed next to each other, cold and hot colors vibrate like fire and ice.

Warm

All hues that contain red are warm. It is the addition of yellow to red that makes warm colors substantially different from hot colors. Warm colors, such as red-orange, orange, and yellow-orange, always contain a mixture of red and yellow in their compo-sition and encompass a larger part of the emotional spectrum.

Warm colors are comforting, sponta-neous, and welcoming. Like an Arizona sunset, the warmth of these hues radiates outward and surrounds everything in reach.

Cool

Cool colors are based in blue. They differ from cold colors because of the addition of yellow to their composition, which creates yellow-green, green, and blue-green. Cool colors, such as turquoise blue and verdant green, are seen in nature. Like spring growth, they make us feel renewed. Soothing and calm, these hues provide a sense of depth as well as comfort. Cool colors are like a swim in a refreshing, tropical pool.

Light

Light colors are the palest pastels. They take their lightness from an absence of visible color in their composition, and are almost transparent. When lightness increases, variations between the different hues decrease.

Light colors open up the surroundings and suggest airiness, rest, and liquidity. They resemble sheer curtains at a window and send a message of relaxation.

Dark

Dark colors are hues that contain black in their composition. They close up space and make it seem smaller. Dark colors are concentrated and serious in their effect. Seasonally, they suggest autumn and winter. Combining lights and darks together is a common and dramatic way to represent the opposites in nature, such as night and day.

Pale

Pale hues are the softest pastels. They contain at least 65 percent white in their composition, and have a diminished hue which is most often referred to as soft or romantic.

Pale colors, like ivory, light blue, and pink, suggest gentleness. They can be seen in the clouds in a soft, early light, or in the lavender colors of a misty morning. Because they are calming colors, pale hues are frequently used in interior spaces.

Bright

The amount of pure color within a hue determines its brightness. The clarity of bright colors is achieved by the omission of gray or black. Blues, reds, yellows, and oranges are colors in full brightness.

Bright colors are vivid and attract attention. A yellow school bus, a bunch of colored balloons, the red of a clown's nose, never go unnoticed. Exhilarating and cheerful, bright colors are perfect for use in packaging, fashion, and advertising.

Basic Color Schemes

No color stands alone. In fact, the effect of a color is determined by many factors: the light reflected from it, the colors that surround it, or the perspective of the person looking at the color.

There are ten basic color schemes. They are called achromatic, analogous, clash, complement, monochromatic, neutral, and split complement, as well as primary, secondary, and tertiary schemes.

105 101 98

ACHROMATIC SCHEME
Without color, uses only black, white, and grays.

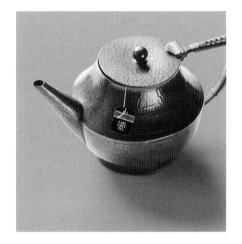

5 16 20

ANALOGOUS SCHEME
Uses any three consecutive hues or any of their tints and shades on the color wheel.

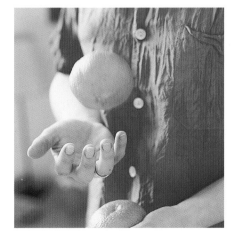

5 68

CLASH SCHEME
Combines a color with the hue to the right or left of its complement on the color wheel.

92 46

COMPLEMENTARY SCHEME
Uses direct opposites on the color wheel.

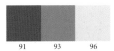

91 93 96

MONOCHROMATIC SCHEME
Uses one hue in combination with any or all of its tints and shades.

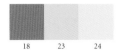

18 23 24

NEUTRAL SCHEME

Uses a hue which has been diminished or neutralized by the addition of its complement or black.

12 52 68

SPLIT COMPLEMENTARY SCHEME

Consists of a hue and the two hues on either side of its complement.

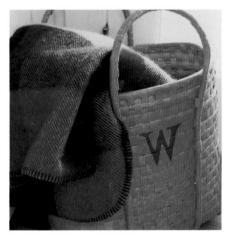

4 36 69

PRIMARY SCHEME

A combination of the pure hues of red, yellow, and blue.

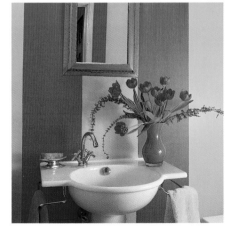

53 83 20

SECONDARY SCHEME

A combination of the secondary hues of green, violet, and orange.

60 28 92

TERTIARY TRIAD SCHEME

A tertiary triad is one of two combinations: red-orange, yellow-green, and blue-violet, or blue-green, yellow-orange, and red-violet; all of which are equidistant from each other on the color wheel.

COLOR COMBINATIONS FOR CREATIVE EFFECTS

The color schemes and combinations on the following pages illustrate over 1,400 color possibilities. Creative color solutions are presented with practical and emotional variations providing a wide range of color uses in all areas of the fine, graphic, and applied arts.

What's Your Color?

Alice might have better understood her adventures in Wonderland if the caterpillar had actually asked, "Hue are you?" That's because colors, like people, have distinct personalities.

So, hue are you? The answer can prove quite revealing. Just ask the power-hungry Red Queen.

RED

You crave excitement and like to live in the moment. Easily bored, you also enjoy having the power to get things done quickly. Red lovers are passionate about life.

PINK

You are sensitive and kind, with a sweet disposition. You wouldn't mind a return to more innocent times, and crave romance in your life.

YELLOW

You are generally happy, playful, and optimistic. If something isn't working in your life, you quickly seek to change it. Spontaneous, you have boundless curiosity.

BLUE

You like a sense of calm and order in your life. Trustworthy, you also value loyalty in others. Sky blue attracts pleasure-seekers and daydreamers, while navy appeals to the serious and conservative.

GRAY

You're a watcher rather than a participator and are reserved in social situations. Generally noncommittal, you don't like to firm up plans until the very last moment.

GREEN

You long to feel safe and make the world a better place for others. You are generous with your time and goodwill, but also can be stubborn about issues that are important to you.

BROWN

You are down-to-earth and a dependable, loyal friend. Your home and family are very important to you, and comfort is a key issue in life.

PURPLE

You are known as a negotiator, and have a strong desire to please. Though well liked, you don't confide easily in others and enjoy a slight sense of mystery.

ORANGE

You are gregarious, dynamic, and fun to be with. Flamboyant by nature, you don't mind sticking out in a crowd. You have a great appetite for life and food.

Special Effects for Color

Necessity may be the mother of invention, but it is our continual quest for change that leads to innovation. This principle has governed color research over the ages.

In ancient Egypt, Cleopatra couldn't exactly send a slave to the drugstore for a new lipstick. So the Queen of the Nile turned instead to her cosmetic wizards, who transformed flower blossoms and fine clay into a cornucopia of lip and cheek rouges and crushed ant eggs into eyeliner.

Artists spent centuries as veritable prisoners in their studios until the invention of pigment tubes, which finally allowed them to paint *en plein air*. The Impressionists' extraordinary marriage of color and light would have been impossible had they not taken their palettes and brushes outdoors.

Today's technological advances in printing have left no new colors to create, so where do we turn for the next wave in color innovation? Just as the ever-changing sunlight on a landscape inspired the Impressionist painters, metallic, opalescent, and fluorescent special effects can transform the way we perceive color. These shimmering finishes catch our eye in subtle or dramatic ways, capturing and reflecting light while adding surface interest and a fresh dimension to the spectrum.

The psychological implications of these special effects also offer designers a new avenue for reaching out to their target markets. Fluorescents pop with an energizing youth and vitality, while metallics and opalescents speak quietly of refined taste and exclusivity.

Do you want to imply affluence? From antique chalices and crowns to the cry of "Eureka!" in the gold rush days, shiny metallics have always held a special, moneyed allure for both the obvious intrinsic value of the ore itself and its use as coin of the realm. But today, the very mention of the word *gold or silver* conjures images of power and success. These colors adorn the best athletes in the world at the Olympic Games and are reserved for the most prestigious customers by credit card companies.

Interestingly, even though gold is the more precious of the two metals, silver has greater appeal to luxury car buyers in Asia, Europe, and the Americas, according to DuPont's annual Global Color Popularity Report. Since icy grays contain none of the warmth associated with gold tones, silver implies an aloofness that sets it apart from the mass market. After all, we say the rich are born with silver spoons in their mouths, not gold.

DuPont suggests that silver also offers "sophisticated automotive styling cues that express technology driven lifestyles." The association of metallics and optical effects with the Computer Age adds to this message of state-of-the-art innovation.

In printing, "things that sparkle and shine tend to get noticed," affirms *Ink World* magazine. But unlike eye-catching reds or oranges, metallics connote money and currency, giving them an impression of extravagance. Silver or gold ink on wedding invitations speaks of ballrooms and chandeliers, while metallic wrapping paper suggests a precious gift inside.

Of course all that glitters goes well beyond gold, or silver for that matter. Metallic finishes can add depth to any hue in the spectrum and are best used to express wealth or breakthrough technology.

Opalescents provoke similar reactions, reminding one of gemstones and lustrous pearls. Even the luminescent interior of an abalone or conch shell lying on the beach gives the impression of buried treasure. In addition to pleasing the eye, opals and pearls can be either classic or unique, so those ethereal finishes appeal to a wide range of tastes.

Consider that style icons like Jacqueline Kennedy Onassis and Audrey Hepburn popularized wearing a single tasteful strand of pearls, always *de rigeur* in proper society. But at the same time, iconoclasts have given pearls a more unconventional twist, as exemplified by provocative dancer Josephine Baker, who wore ropes and ropes of pearls in her act, and not much else.

An attraction to opalescent finishes isn't exclusive to women. Lustrous sheens in products and packaging also appeal to men who want to express a sense of non-conformity without being overt. When men buy sun- or eyeglass frames, for example, they prefer interesting surface finishes that mottle the color, making it more distinctive.

And for that all-important automobile purchase, metallic or opalescent effects exude class and originality. Anyone can own a white car, the thinking goes, but one that has a pearlized cream finish that changes color depending on the time of day makes more of a statement sitting in the driveway.

If you really want to catch your neighbor's eye, though, fluorescents are the way to go. No other colors command immediate attention as effectively.

Favored by children, playful designers, and athletic-wear manufacturers, fluorescent colors offer a kitschy, retro feeling reminiscent of neon signs and roadside diners. But there's a practical side as well. As the most conspicuous color effect, Day-Glo brights are ideal for running shoes and outdoor apparel to make athletes and children more noticeable at night.

That's why fluorescents are the finish of choice for emergency equipment and signs. Brilliant yellow road signs pop out against the pavement, rapidly alerting drivers to potential hazards, while high-intensity orange life preservers silently call out to rescue boats. Construction workers and crossing guards would be in greater danger if their bright orange vests didn't set them apart from oncoming traffic.

Lime green is the ideal choice for billboards or equipment that need to be seen at night. Research has proven that reflective fluorescent lime is the most visible color in the dark, as well as in poor weather conditions such as fog.

In fact, safety-research studies of fire engines found that when they were painted lime green, the trucks were involved in half the number of traffic accidents, especially at night. So why aren't all fire trucks now painted lime? Because red proved too iconic with the public, which psychologically couldn't accept such a major color change.

That can be a great advantage of special-effects finishes: Applying them lets you change the look of an existing product without altering its accepted color.

A French rosary manufacturer did precisely that in the 1600s by artificially creating pearlescent pigments to give its beads a suitably ethereal presence. The desired effect was achieved by scraping the skin and scales of whitefish.

Today, mica crystals, both natural and synthetic, produce all light-reflecting iridescence. But as was true in the seventeenth century, the popularity of these finishes is due in part to our renewed spirituality in troubled times.

Luminosity is prized for more down-to-earth reasons as well, with mica being seen as an indispensable ingredient in cosmetic foundations that promise a "youthful glow."

Car finishes, however, need to last a lot longer than makeup applications. It took years of research for the automotive industry to develop pearlized effects that could pass the standard three-year durability test for heat stability and weather-fastness.

Metallic car colors underwent their own ingredient makeover to guarantee longevity. The metal flakes used in the 1950s required so many clear top coats that the top coats often cracked and yellowed. Mylar-coated flakes are used today.

A leader in the science of color management, DuPont used knowledge accumulated while researching automotive finishes to make special-effects printing more predictable. The performance of metallic inks has also improved in recent years, resulting in substantial market growth.

Luxurious

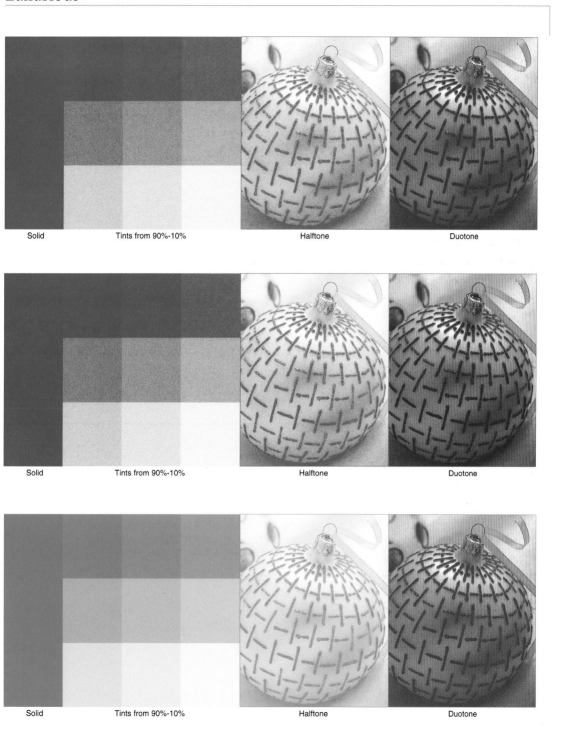

Solid Tints from 90%-10% Halftone Duotone

Solid Tints from 90%-10% Halftone Duotone

Solid Tints from 90%-10% Halftone Duotone

Sophisticated

Solid Tints from 90%-10% Halftone Duotone

Solid Tints from 90%-10% Halftone Duotone

Solid Tints from 90%-10% Halftone Duotone

Eco-Friendly

Solid Tints from 90%-10% Halftone Duotone

Solid Tints from 90%-10% Halftone Duotone

Solid Tints from 90%-10% Halftone Duotone

Corporate

Solid Tints from 90%-10% Halftone Duotone

Solid Tints from 90%-10% Halftone Duotone

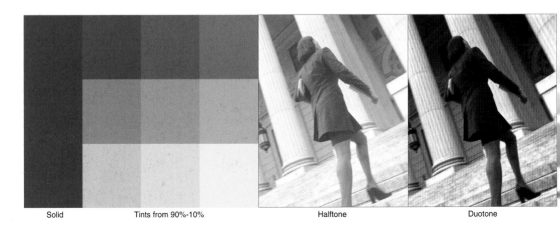

Solid Tints from 90%-10% Halftone Duotone

Elemental

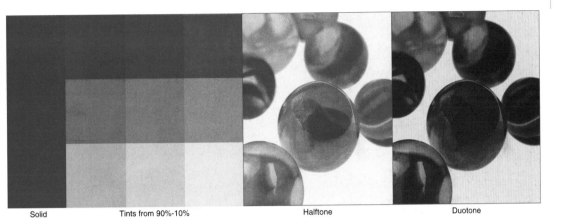

Solid Tints from 90%-10% Halftone Duotone

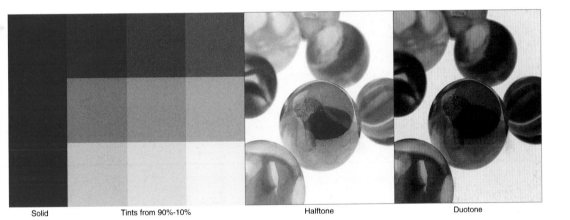

Solid Tints from 90%-10% Halftone Duotone

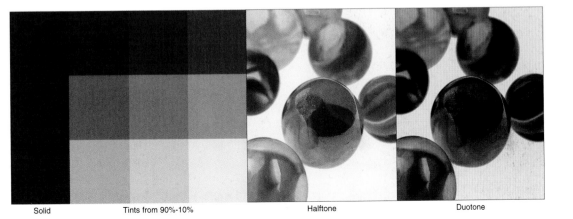

Solid Tints from 90%-10% Halftone Duotone

Organic

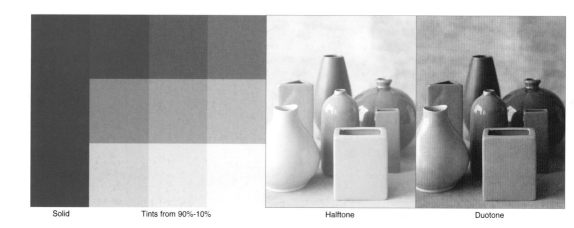

Solid Tints from 90%-10% Halftone Duotone

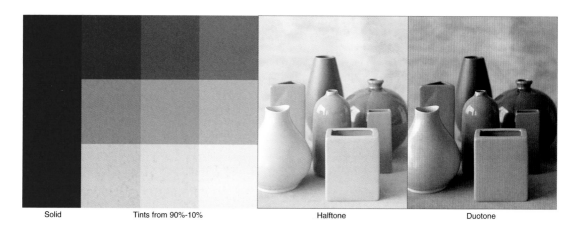

Solid Tints from 90%-10% Halftone Duotone

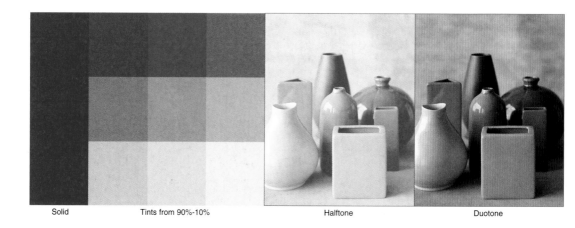

Solid Tints from 90%-10% Halftone Duotone

Formal

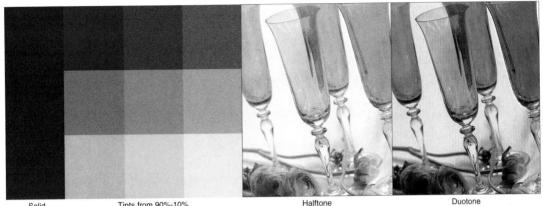

Solid Tints from 90%-10% Halftone Duotone

Solid Tints from 90%-10% Halftone Duotone

Solid Tints from 90%-10% Halftone Duotone

Festive

Solid Tints from 90%-10% Halftone Duotone

Solid Tints from 90%-10% Halftone Duotone

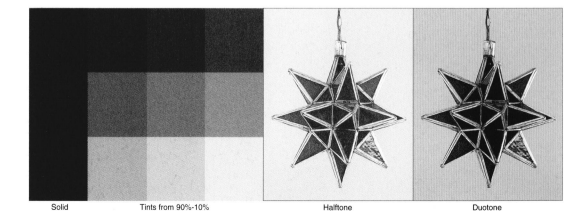

Solid Tints from 90%-10% Halftone Duotone

Exotic

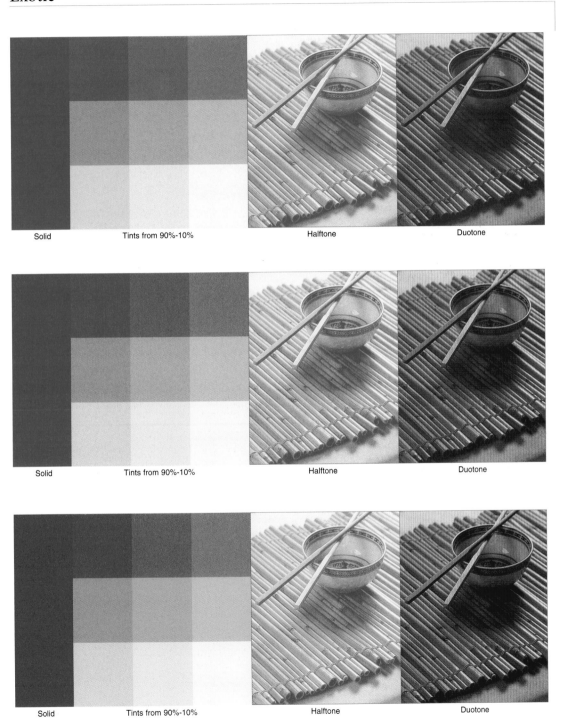

Solid Tints from 90%-10% Halftone Duotone

Solid Tints from 90%-10% Halftone Duotone

Solid Tints from 90%-10% Halftone Duotone

Old-Fashioned

Solid Halftone Duotone

Retro

Solid Halftone Duotone

Happy

Solid Halftone Duotone

Safety

Solid Halftone Duotone

Fun and Wild

Solid Halftone Duotone

Sweet

Solid Halftone Duotone

Pretty

Solid Halftone Duotone

Girly

Solid Halftone Duotone

And What's Next?

The industry magazine *Ward's Auto World* predicts that "effects such as matte and gloss, reflective and iridescent, and opaque and phosphorescent, are some of the new automotive coating trends expected to show up on dealer lots in the next few years." Holographic, refractive, and glow-in-the-dark color research is also underway, not only for use on cars, but in product packaging as well.

This means big business for many industries. When glow-in-the-dark material was first produced in children's sneakers, for example, the resulting effect proved irresistible to both boys and girls, greatly boosting sales.

Once the technology is perfected, the next step involves romancing the consumer. That's why color naming has become a science unto itself, coining monikers that are as visual as they are vivid.

The experts at the Color Marketing Group have always been especially inventive. Metallic names have included Shimma, "a shimmer, a shake, a little golden flake"; Fortune Teller, "a deepened, metallic hue that looks into the future of gray and silver"; Champagne Bubble, "celebrating the marriage of Silver to Gold with Art Deco glamour"; and Root Beer, a copper-based rich brown with "pop."

From the Ralph Lauren paint line come Looking Glass Slipper, Ballroom Gold, and Oyster Pearl, all bringing to mind the elegant luster of Lauren's Duchesse Satin wall finish.

Feel the need for speed? Harley-Davidson can rev up your engine with the custom colors Sinister Blue Pearl or Arresting Red. And what child wouldn't be happy with a playroom painted fluorescent Saturn Yellow, Blaze Orange, or Rocket Red?

But whether tantalized by the name or the multicolored finish, "the human eye is always stimulated by novelty," according to experts at Pantone. Technological advances in special-effects color finishes should keep delivering surprises for many years to come.

Moods and Color

Nothing creates a mood faster than color. It affects our senses, our outlook, even our behavior. Fiesta brights at a party make you hungry for food and fun. The steely grays of a lawyer's office suggest you should quietly take a seat. The icy blues of a swimming pool invite you to cool off.

Interesting color combinations can stop you in your tracks, change your perspective, or make you look at a product in a whole new way. After all, would you want to dive into a red and orange pool on a hot summer's day?

The dilemma facing most people is figuring out how to choose the right colors. If you have chosen a main color, how do you choose accent colors? How do you create a color palette that is both aesthetically appealing and sends the right message to the world? What messages do colors convey?

This chapter provides you with more than 1,000 different color combinations, using one-, two-, and three-color palettes. Each palette range is based on a specific mood adjective, which helps the reader find the right color palettes for his or her chosen mood or style. Each palette is illustrated with an evocative image that helps the reader determine the feeling he or she is looking for and, once the right mood is chosen, the provided palettes demonstrate the available colors and how they work together.

So while you are reviewing the vast array of color combinations in this book, keep both aesthetics and mood in mind. You are now armed with the basics of color theory from the first half of this book so, whether you're looking for a tone that is cheerful, elegant, somber, refreshing, calming, or energizing, you can now let color harmony be your emotional guide.

Powerful

The most powerful combinations, full of excitement and control, are always associated with the color red. No matter what color it is combined with, red can never be ignored. It is the ultimate "power" color—forceful, bold, and extreme. Powerful color combinations are symbols of our strongest emotions, love and hate. They represent emotional overdrive.

In advertising and display, powerful color combinations are used to send a strong message of vitality and awareness. They always attract attention.

SPLIT

57 44 6 61 46 4 58 41 1 63 42 6

CLASH

60 4 61 6 59 7 57 3

44 4 41 7 42 8 43 1

NEUTRAL

1 8 1 4 2 4 3 4

98 100 4 101 4 105 4 98 104 97 102 4

53
POWERFUL

Rich

Richness in a color can be created by combining a powerful *hue* with its darkened complement. For example, deep burgundy results from adding black to red, and, like a fine old wine from a French vineyard, it signifies wealth. Burgundy and deep forest green used together with gold suggest affluence. These dark, sumptuous colors—used in textures as diverse as leather and taffeta—create a dramatic, unforgettable effect. They will always reveal a sense of wealth and status.

ANALOGOUS

SPLIT COMPLEMENTARY

81	89	1
82	91	2
84	90	3
88	92	1

89	1	9
90	2	11
94	2	10
3	95	10

1	9	17
2	11	17
3	10	19
1	19	9

57	1	41
58	1	42
62	1	46
64	1	45

61	2	42
58	2	43
60	3	41
63	3	45

SPLIT

| 1 | 41 | 57 | | 2 | 46 | 63 | | 1 | 42 | 59 | | 3 | 45 | 62 |

CLASH

| 41 | 1 | | 45 | 2 | | 43 | 1 | | 46 | 1 |

| 57 | 3 | | 59 | 2 | | 57 | 2 | | 62 | 1 |

NEUTRAL

| 51 | 2 | | 50 | 3 | | 54 | 1 | | 49 | 1 |

| 98 | 100 | 1 | | 101 | 2 | 105 | | 1 | 98 | 104 | | 97 | 102 | 3 |

Romantic

Pink suggests romance. Pink is white added to red in varying amounts and is the lightened value of red. Like red, pink arouses interest and excitement, but in a softer, quieter way.

A romantic color scheme using pastel tints of pink, lavender, and peach will read as gentle and tender. Combined with other bright pastels, pink evokes memories of dreamy June days and full bouquets of delicate, summer flowers.

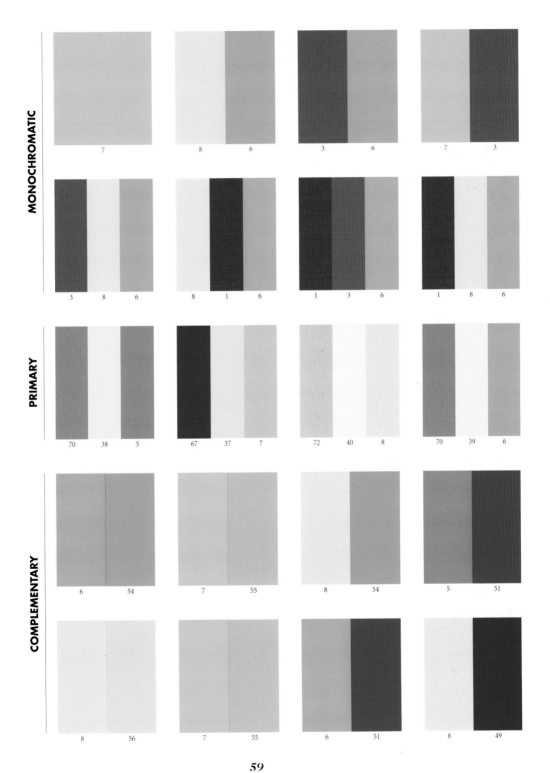

MONOCHROMATIC

PRIMARY

COMPLEMENTARY

7

8 6

3 6

7 3

3 8 6

8 1 6

1 3 6

1 8 6

70 38 5

67 37 7

72 40 8

70 39 6

6 54

7 55

8 54

5 51

8 56

7 55

6 51

8 49

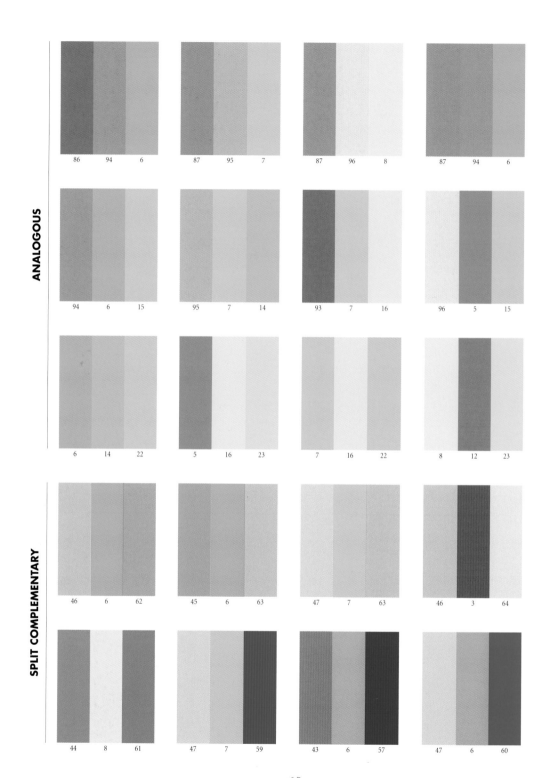

ANALOGOUS

SPLIT COMPLEMENTARY

86	94	6
87	95	7
87	96	8
87	94	6

94	6	15
95	7	14
93	7	16
96	5	15

6	14	22
5	16	23
7	16	22
8	12	23

46	6	62
45	6	63
47	7	63
46	3	64

44	8	61
47	7	59
43	6	57
47	6	60

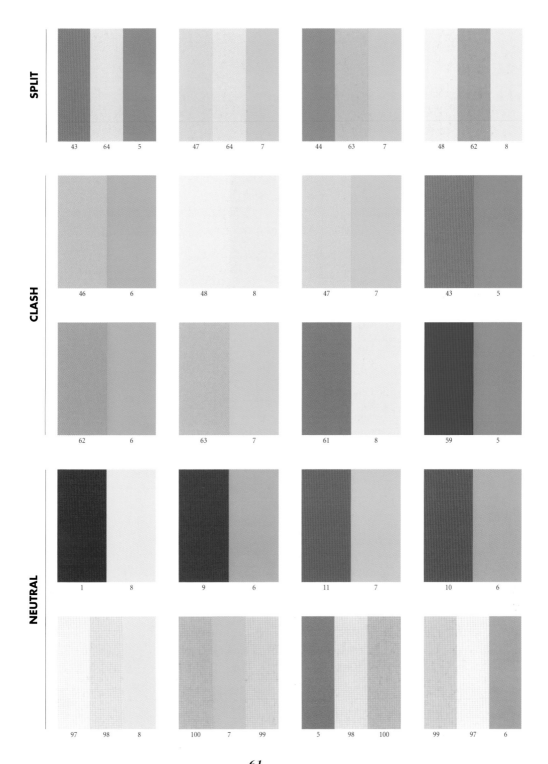

SPLIT

43 64 5 47 64 7 44 63 7 48 62 8

CLASH

46 6 48 8 47 7 43 5

62 6 63 7 61 8 59 5

NEUTRAL

1 8 9 6 11 7 10 6

97 98 8 100 7 99 5 98 100 99 97 6

Vital

Vitality and enthusiasm are best promoted in design and graphics by using the hue most commonly known as vermillion, or any of its many tints and shades. By using color combinations with this red-orange hue at the center, a feeling of vigor and warmth can easily be created. These combinations are youthful and playful and are often seen in advertisements displaying energetic lifestyles and personalities. The combination of red-orange partnered with its complement, turquoise, is active, easy to be around, and is very effective when used in fabrics, advertising, and packaging.

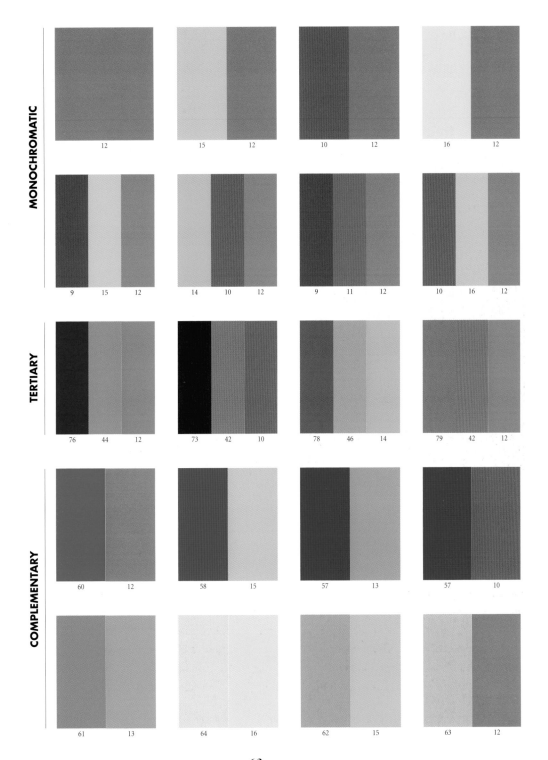

MONOCHROMATIC

12

15 12

10 12

16 12

9 15 12

14 10 12

9 11 12

10 16 12

TERTIARY

76 44 12

73 42 10

78 46 14

79 42 12

COMPLEMENTARY

60 12

58 15

57 13

57 10

61 13

64 16

62 15

63 12

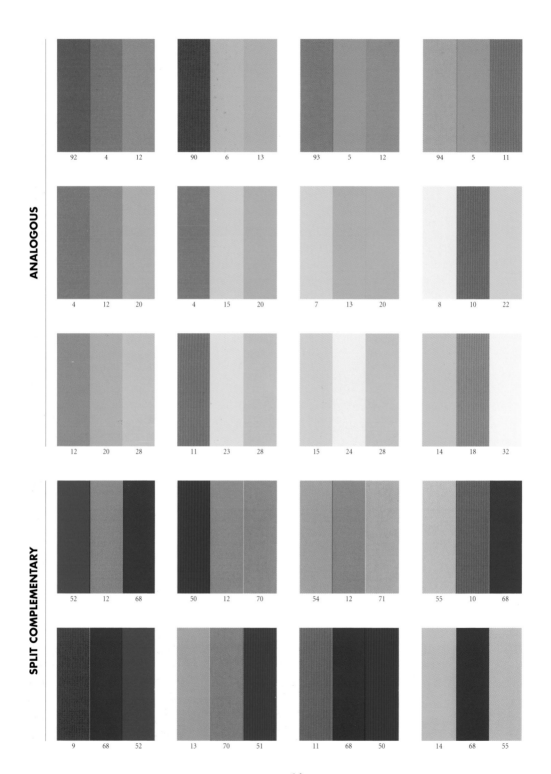

ANALOGOUS

| 92 | 4 | 12 | | 90 | 6 | 13 | | 93 | 5 | 12 | | 94 | 5 | 11 |

| 4 | 12 | 20 | | 4 | 15 | 20 | | 7 | 13 | 20 | | 8 | 10 | 22 |

| 12 | 20 | 28 | | 11 | 23 | 28 | | 15 | 24 | 28 | | 14 | 18 | 32 |

SPLIT COMPLEMENTARY

| 52 | 12 | 68 | | 50 | 12 | 70 | | 54 | 12 | 71 | | 55 | 10 | 68 |

| 9 | 68 | 52 | | 13 | 70 | 51 | | 11 | 68 | 50 | | 14 | 68 | 55 |

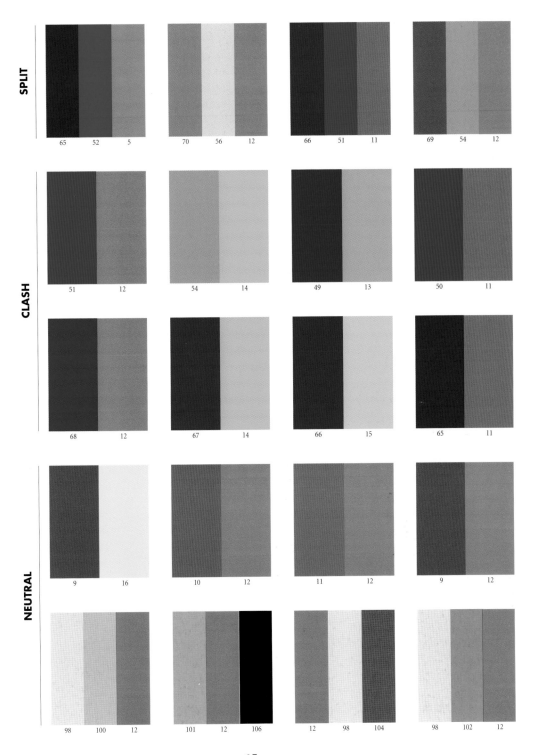

SPLIT

65 52 5 70 56 12 66 51 11 69 54 12

CLASH

51 12 54 14 49 13 50 11

68 12 67 14 66 15 65 11

NEUTRAL

9 16 10 12 11 12 9 12

98 100 12 101 12 106 12 98 104 98 102 12

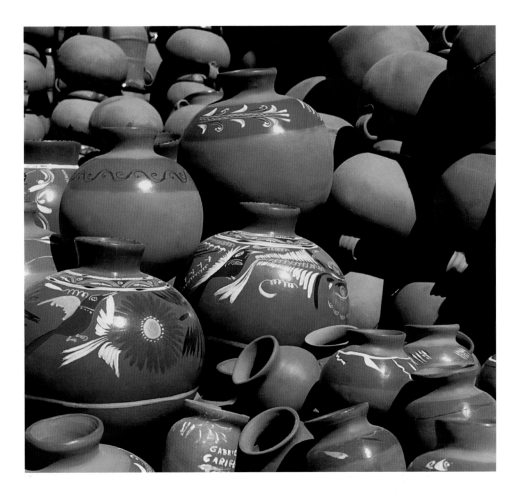

Earthy

Rich, warm, and full of vitality, earthy color combinations frequently use the dark, vivid red-orange called terra-cotta. Terra-cotta suggests subtle warmth, like polished copper. When used with white, it projects a brilliant, natural combination.

Earthy hues reflect fun-loving youth, and call to mind leisure living. As part of an analogous scheme, these warm, earthy tones generate exciting combinations, such as those seen in the decor of the American West.

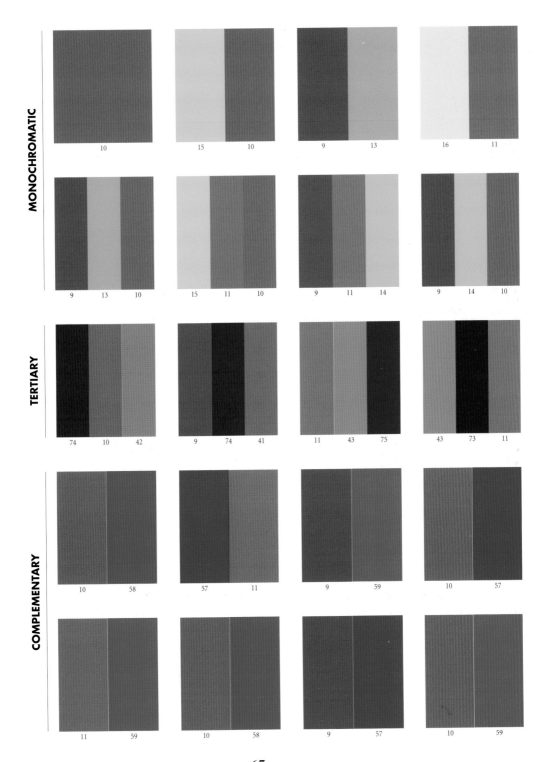

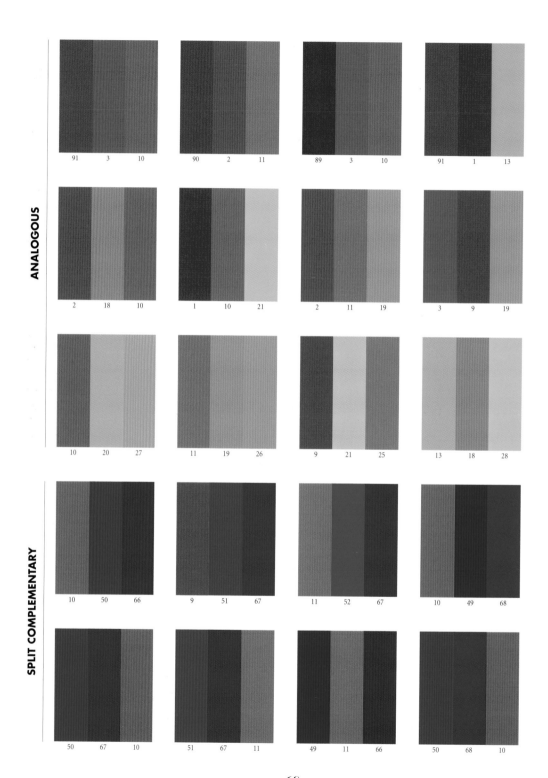

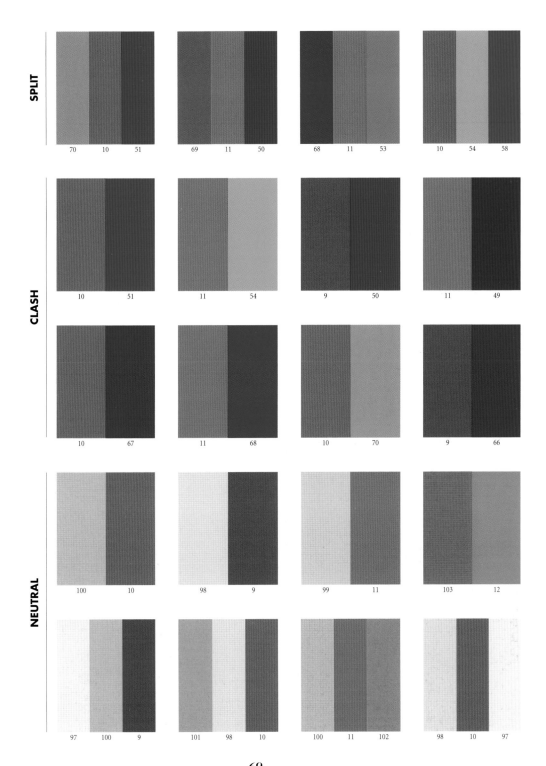

SPLIT

70 10 51 69 11 50 68 11 53 10 54 58

CLASH

10 51 11 54 9 50 11 49

10 67 11 68 10 70 9 66

NEUTRAL

100 10 98 9 99 11 103 12

97 100 9 101 98 10 100 11 102 98 10 97

Friendly

Color schemes that convey friendli-
ness often include orange. Open and easy,
these combinations have all the elements
of energy and movement. They create
order and equality without a sense of
power or control.

Orange along with its color wheel
neighbors is frequently used in fast-food
restaurants because it projects an inviting
message of good food at a friendly price.
Because it is energetic and glowing, orange
is the international safety color in areas of
danger. Orange life rafts and life preservers
are easily seen on blue or gray seas.

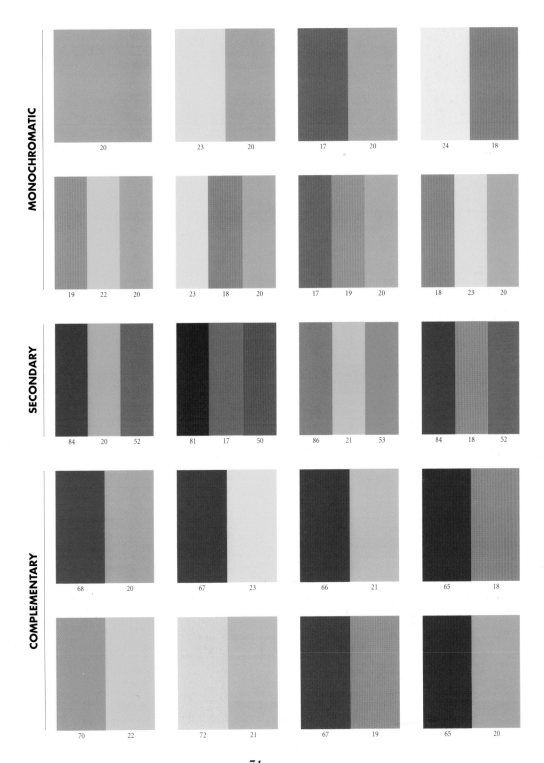

20

23 20

17 20

24 18

19 22 20

23 18 20

17 19 20

18 23 20

84 20 52

81 17 50

86 21 53

84 18 52

68 20

67 23

66 21

65 18

70 22

72 21

67 19

65 20

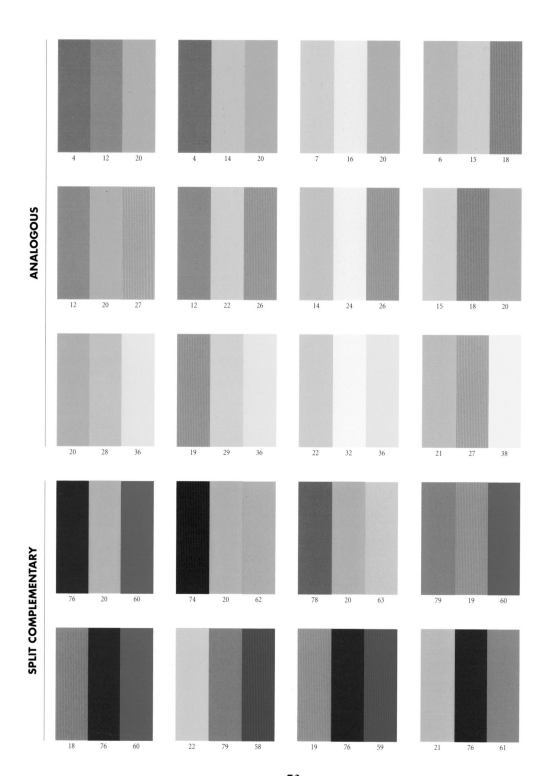

4	12	20
4	14	20
7	16	20
6	15	18

12	20	27
12	22	26
14	24	26
15	18	20

20	28	36
19	29	36
22	32	36
21	27	38

76	20	60
74	20	62
78	20	63
79	19	60

18	76	60
22	79	58
19	76	59
21	76	61

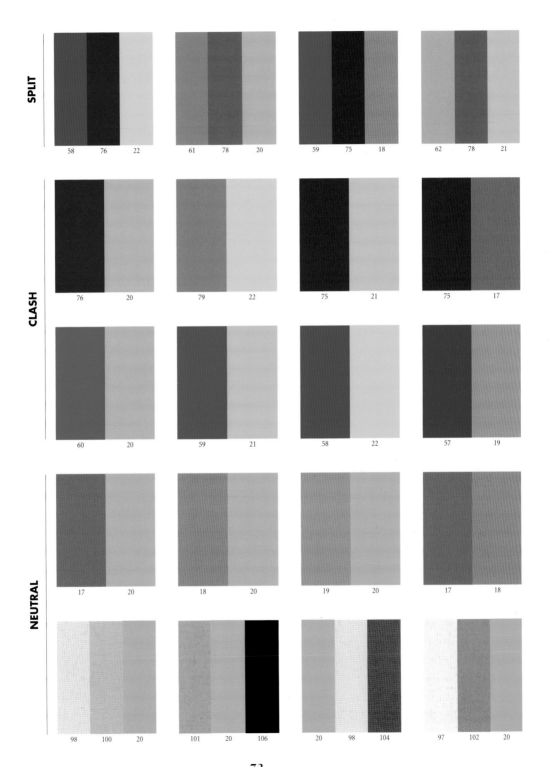

SPLIT

58 76 22 61 78 20 59 75 18 62 78 21

CLASH

76 20 79 22 75 21 75 17

60 20 59 21 58 22 57 19

NEUTRAL

17 20 18 20 19 20 17 18

98 100 20 101 20 106 20 98 104 97 102 20

Soft

Light-valued tints without high contrast are the most comfortable to use when creating soft color combinations. Peach, as part of a muted palette, is delicious and appealing in its color message and workable in any setting, from restaurants to store displays to fashion. When combined with tints of violet and green, it becomes part of a subdued but magical secondary color scheme.

These soft and relaxing colors are often ideal for home decor. The combinations are cheerful and outgoing, while at the same time calm and inviting.

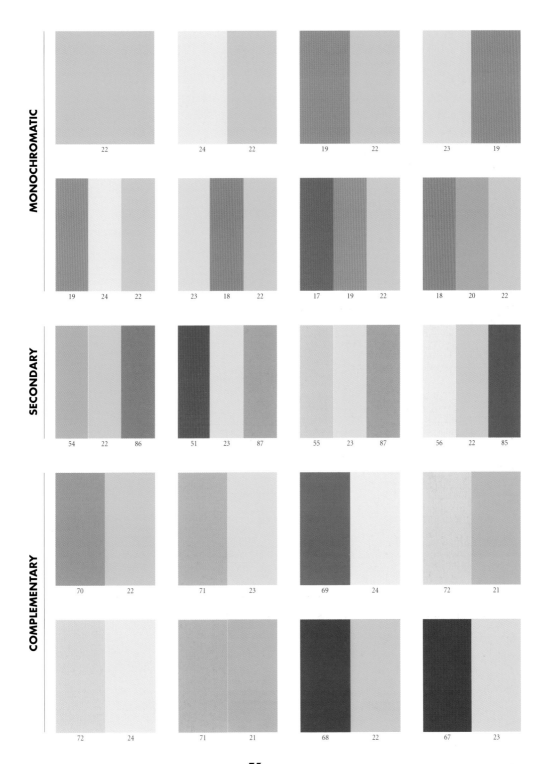

MONOCHROMATIC

22

24 22

19 22

23 19

19 24 22

23 18 22

17 19 22

18 20 22

SECONDARY

54 22 86

51 23 87

55 23 87

56 22 85

COMPLEMENTARY

70 22

71 23

69 24

72 21

72 24

71 21

68 22

67 23

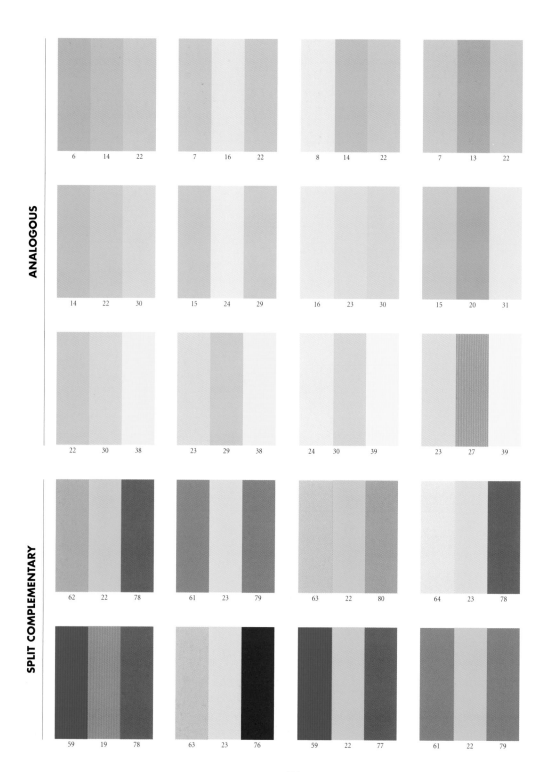

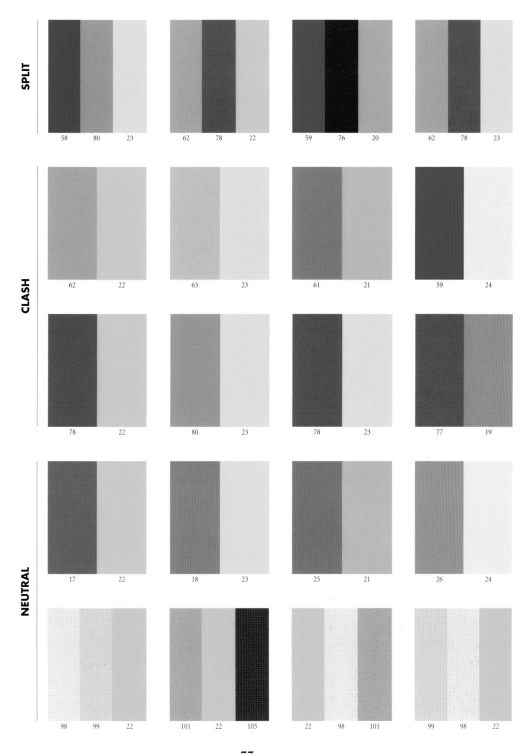

SPLIT

58	80	23
62	78	22
59	76	20
62	78	23

CLASH

62	22
63	23
61	21
59	24

78	22
80	23
78	23
77	19

NEUTRAL

17	22
18	23
25	21
26	24

98	99	22
101	22	105
22	98	101
99	98	22

Welcoming

Color combinations using yellow-orange or amber are the most welcoming. Yellow combined with a small amount of red creates these radiant hues which are universally appealing. In full strength, yellow-orange or amber can be likened to gold or the precious spice saffron. A monochromatic color scheme of saffron used with white is one of classic beauty and is very inviting.

Combinations made with pale amber are warm and congenial. This hue can be used in a variety of applications that call for creamy tints to express festive and cordial environments.

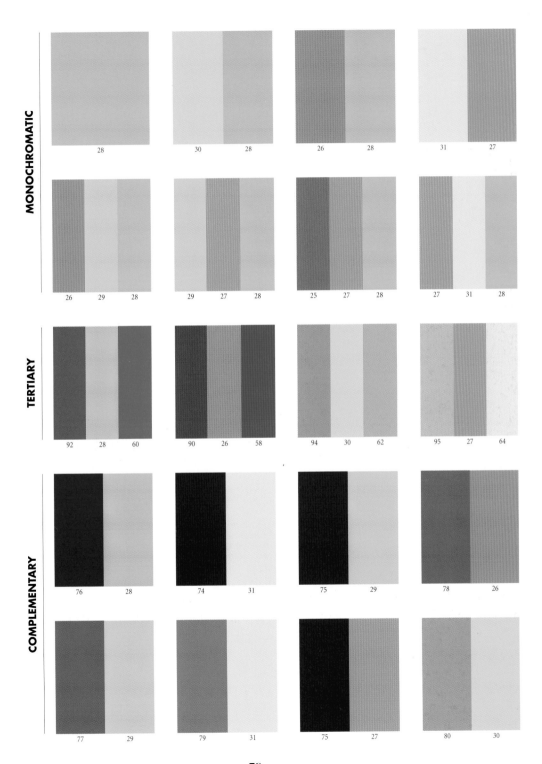

28

30 28

26 28

31 27

26 29 28

29 27 28

25 27 28

27 31 28

92 28 60

90 26 58

94 30 62

95 27 64

76 28

74 31

75 29

78 26

77 29

79 31

75 27

80 30

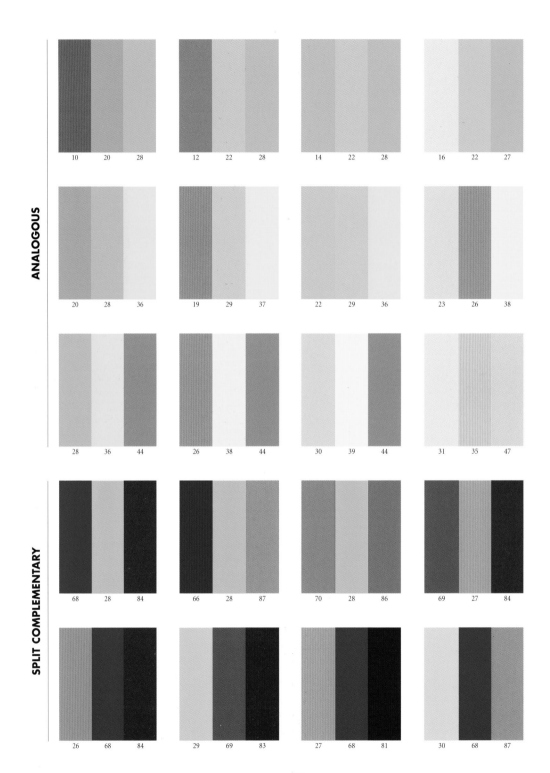

ANALOGOUS

| 10 | 20 | 28 | | 12 | 22 | 28 | | 14 | 22 | 28 | | 16 | 22 | 27 |

| 20 | 28 | 36 | | 19 | 29 | 37 | | 22 | 29 | 36 | | 23 | 26 | 38 |

| 28 | 36 | 44 | | 26 | 38 | 44 | | 30 | 39 | 44 | | 31 | 35 | 47 |

SPLIT COMPLEMENTARY

| 68 | 28 | 84 | | 66 | 28 | 87 | | 70 | 28 | 86 | | 69 | 27 | 84 |

| 26 | 68 | 84 | | 29 | 69 | 83 | | 27 | 68 | 81 | | 30 | 68 | 87 |

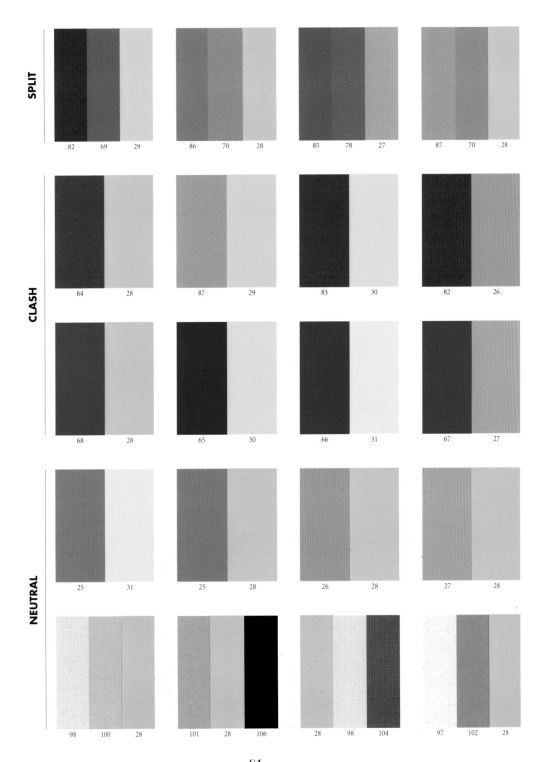

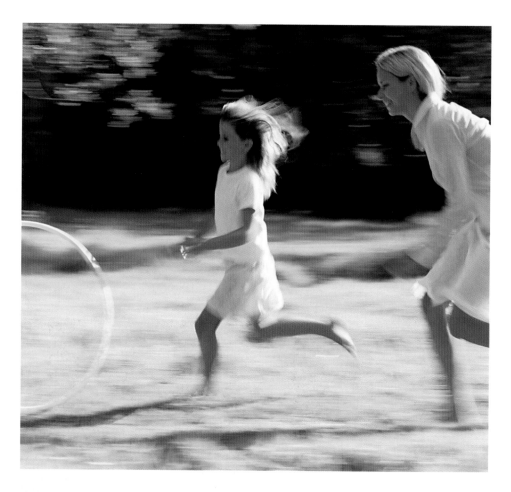

Moving

The brightest color combinations are those that have primary yellow at the center. Yellow expresses life-giving sun, activity, and constant motion. When white is added to yellow, its luminous quality increases and the overall effect is one of extraordinary brightness.

Color schemes of high contrast, such as yellow with its complement violet, mean activity and motion. These palettes generate movement, especially within a round space. It is almost impossible to feel despondent when surrounded by a combination using yellow or any of its tints.

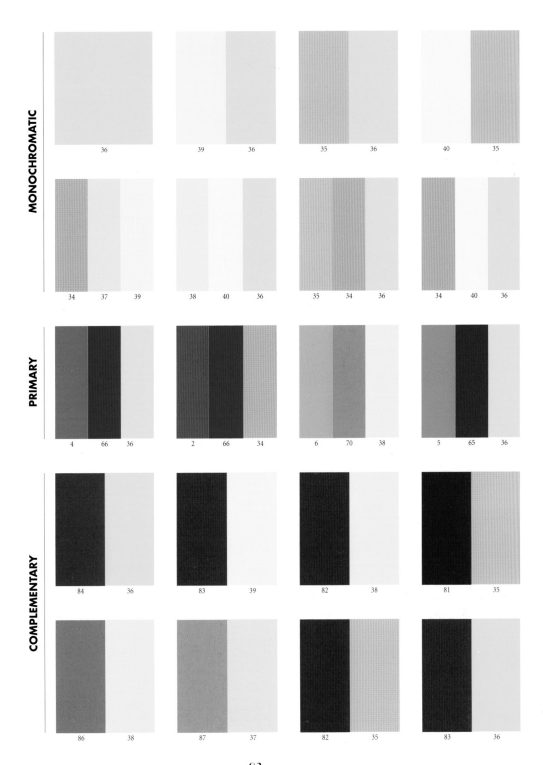

MONOCHROMATIC

36

39 36

35 36

40 35

34 37 39

38 40 36

35 34 36

34 40 36

PRIMARY

4 66 36

2 66 34

6 70 38

5 65 36

COMPLEMENTARY

84 36

83 39

82 38

81 35

86 38

87 37

82 35

83 36

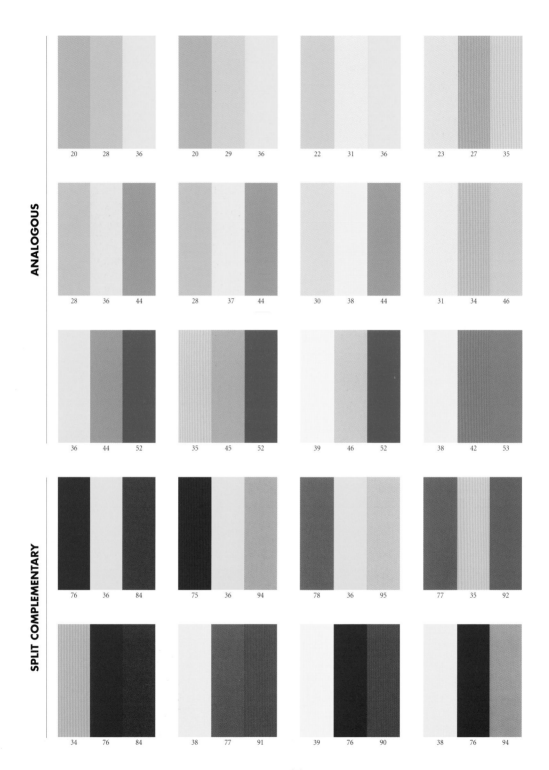

| 20 | 28 | 36 | | 20 | 29 | 36 | | 22 | 31 | 36 | | 23 | 27 | 35 |

| 28 | 36 | 44 | | 28 | 37 | 44 | | 30 | 38 | 44 | | 31 | 34 | 46 |

| 36 | 44 | 52 | | 35 | 45 | 52 | | 39 | 46 | 52 | | 38 | 42 | 53 |

| 76 | 36 | 84 | | 75 | 36 | 94 | | 78 | 36 | 95 | | 77 | 35 | 92 |

| 34 | 76 | 84 | | 38 | 77 | 91 | | 39 | 76 | 90 | | 38 | 76 | 94 |

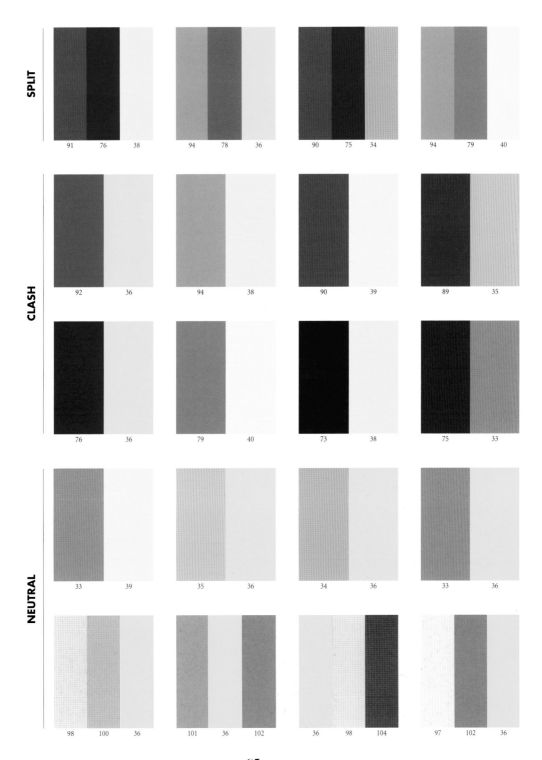

SPLIT

91 76 38 94 78 36 90 75 34 94 79 40

CLASH

92 36 94 38 90 39 89 35

76 36 79 40 73 38 75 33

NEUTRAL

33 39 35 36 34 36 33 36

98 100 36 101 36 102 36 98 104 97 102 36

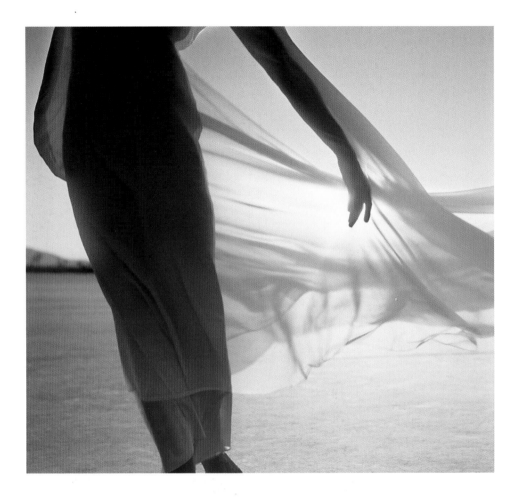

Elegant

Elegant color combinations use only the palest tints. For example, a whisper of yellow combined with white makes a pastel cream, which can be used to create a warmer version of an all-white room. The presence of natural light produces subtle shadows and highlights architectural details, which help to fashion an elegant setting.

Palettes that combine hues similar to the color of eggshells and linens are compatible with most other hues and offer a workable alternative to achromatic white or noncolor schemes. In fashion, elegant linens, silks, wools, and velvets in creamy tones give the impression of ease and opulence by creating a look of classic understatement.

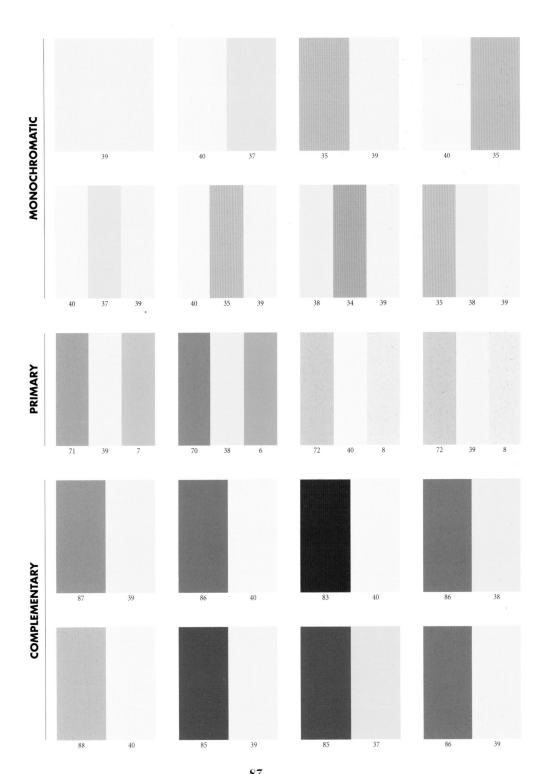

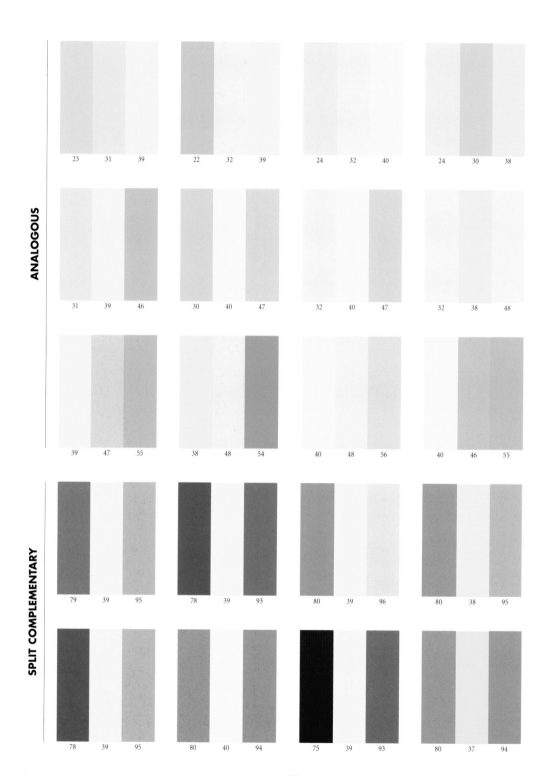

ANALOGOUS

| 23 | 31 | 39 | | 22 | 32 | 39 | | 24 | 32 | 40 | | 24 | 30 | 38 |

| 31 | 39 | 46 | | 30 | 40 | 47 | | 32 | 40 | 47 | | 32 | 38 | 48 |

| 39 | 47 | 55 | | 38 | 48 | 54 | | 40 | 48 | 56 | | 40 | 46 | 55 |

SPLIT COMPLEMENTARY

| 79 | 39 | 95 | | 78 | 39 | 93 | | 80 | 39 | 96 | | 80 | 38 | 95 |

| 78 | 39 | 95 | | 80 | 40 | 94 | | 75 | 39 | 93 | | 80 | 37 | 94 |

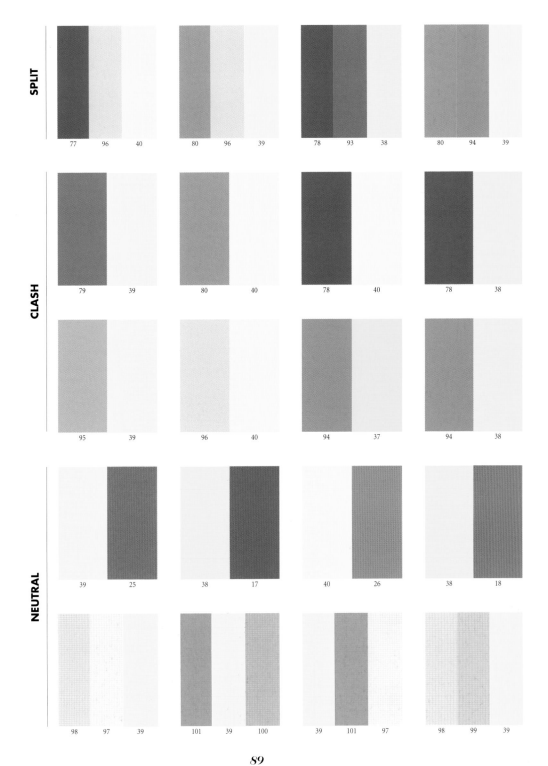

SPLIT

77 96 40 80 96 39 78 93 38 80 94 39

CLASH

79 39 80 40 78 40 78 38

95 39 96 40 94 37 94 38

NEUTRAL

39 25 38 17 40 26 38 18

98 97 39 101 39 100 39 101 97 98 99 39

Trendy

What's "in" today may be "out" to-morrow. Trendy color schemes can be pleasantly shocking in combination with other colors. Chartreuse is an excellent example of an accent color used in youthful and offbeat objects. This brilliant hue takes part in countless successful color combinations used in fashion, from basketball shoes to sweaters. A combination of exquisite contrast is yellow-green or chartreuse paired with its perfect complement, magenta.

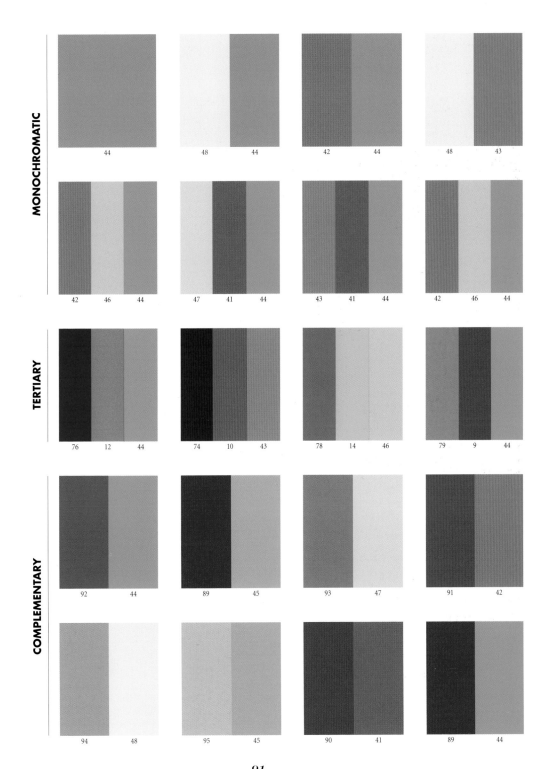

MONOCHROMATIC

44

48 44

42 44

48 43

42 46 44

47 41 44

43 41 44

42 46 44

TERTIARY

76 12 44

74 10 43

78 14 46

79 9 44

COMPLEMENTARY

92 44

89 45

93 47

91 42

94 48

95 45

90 41

89 44

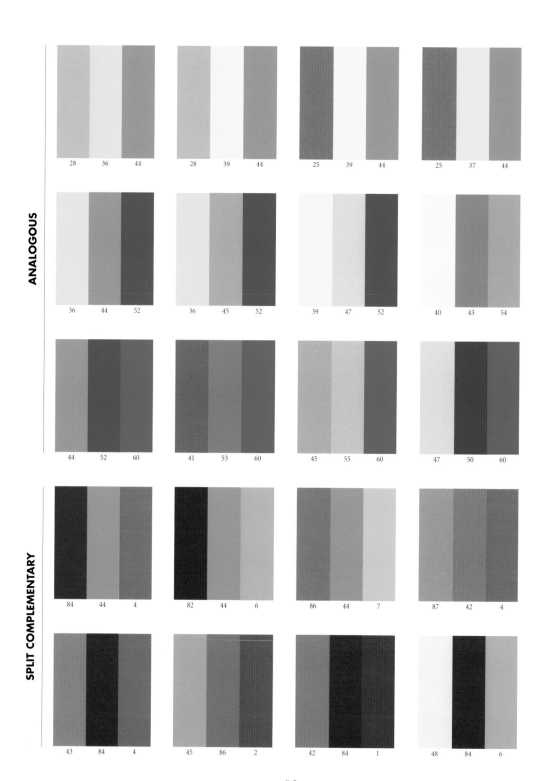

28	36	44

28	39	44

25	39	44

25	37	44

36	44	52

36	45	52

39	47	52

40	43	54

44	52	60

41	53	60

45	55	60

47	50	60

84	44	4

82	44	6

86	44	7

87	42	4

43	84	4

45	86	2

42	84	1

48	84	6

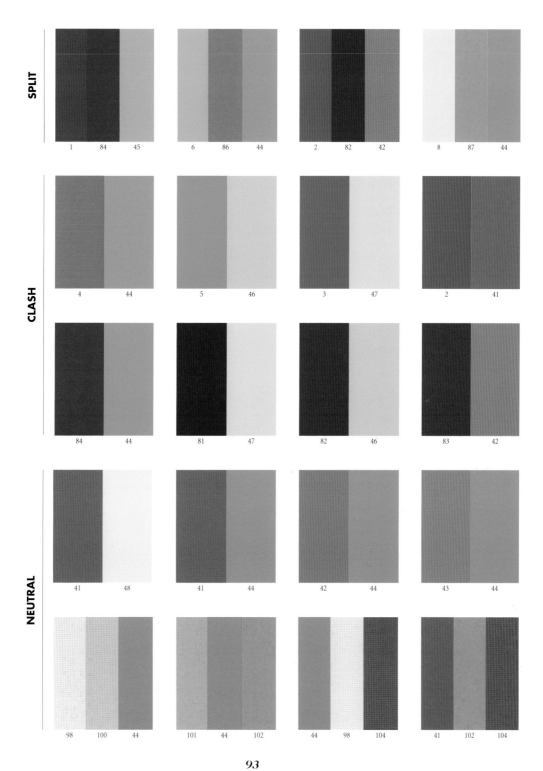

SPLIT

1	84	45
6	86	44
2	82	42
8	87	44

CLASH

4	44
5	46
3	47
2	41

84	44
81	47
82	46
83	42

NEUTRAL

41	48
41	44
42	44
43	44

98	100	44
101	44	102
44	98	104
41	102	104

Fresh

Possessing equal amounts of blue and yellow, green suggests health and prosperity. Although weak in its softest tints, green, a recessive hue, only needs to be combined with small amounts of its strong complement, red, to increase its vitality. Using colors analogous to green on the color wheel will create strong color combinations that resemble vivid, outdoor environments. Like newly mowed grass on a clear day, sky blue and green always look fresh and natural together.

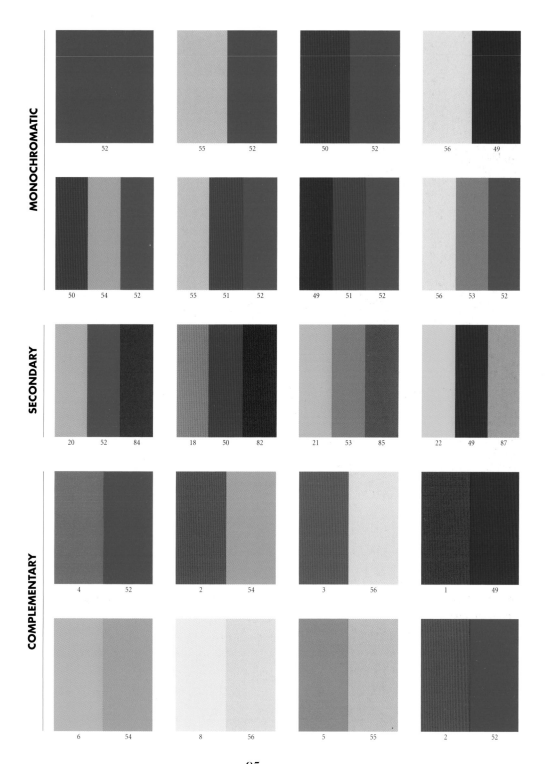

MONOCHROMATIC

52

55 52

50 52

56 49

50 54 52

55 51 52

49 51 52

56 53 52

SECONDARY

20 52 84

18 50 82

21 53 85

22 49 87

COMPLEMENTARY

4 52

2 54

3 56

1 49

6 54

8 56

5 55

2 52

95
FRESH

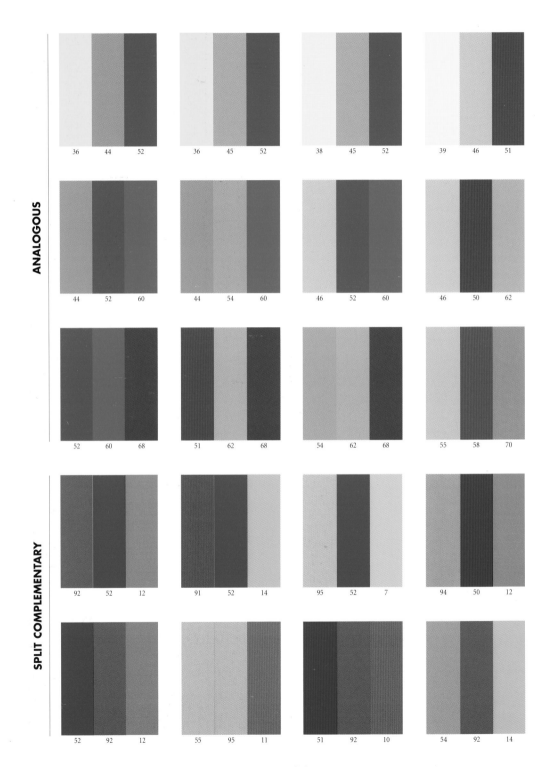

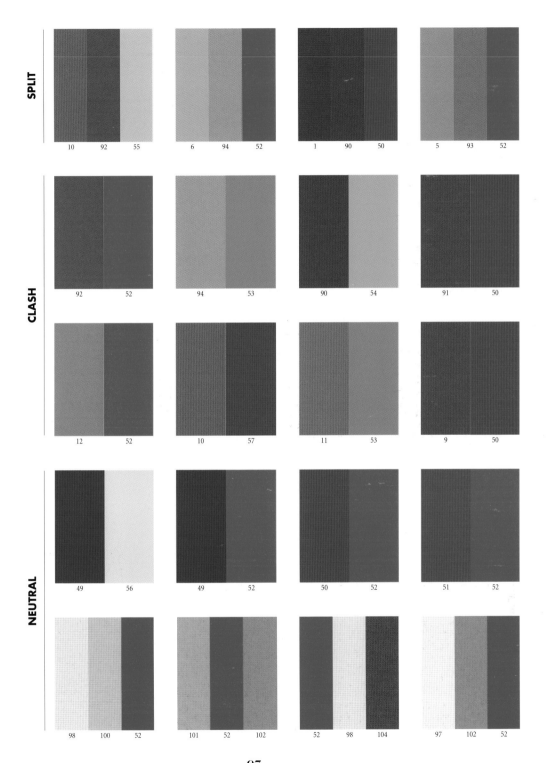

SPLIT

10	92	55
6	94	52
1	90	50
5	93	52

CLASH

92	52
94	53
90	54
91	50

12	52
10	57
11	53
9	50

NEUTRAL

49	56
49	52
50	52
51	52

98	100	52
101	52	102
52	98	104
97	102	52

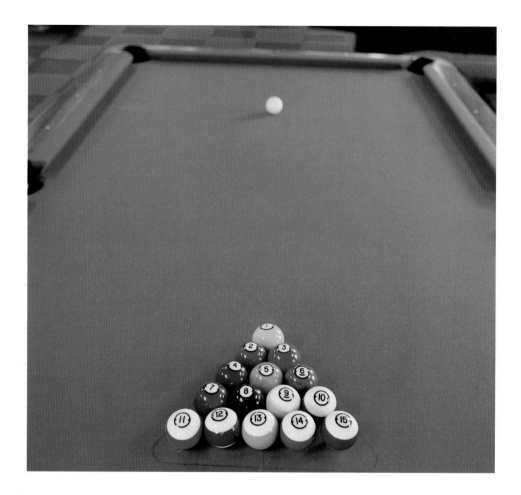

Traditional

Traditional color combinations are often copied from those with historical significance. Conservative colors of blue, burgundy, tan, and green in their grayed or deepened hues, express traditional themes. For example: green, in both its full hue and grayed shades, always signi-

fies possession. Hunter green combined with deep gold or burgundy, or in combination with black, suggests richness and stability. Hunter green is frequently seen in the decor of banks and legal offices, where it suggests permanence and value.

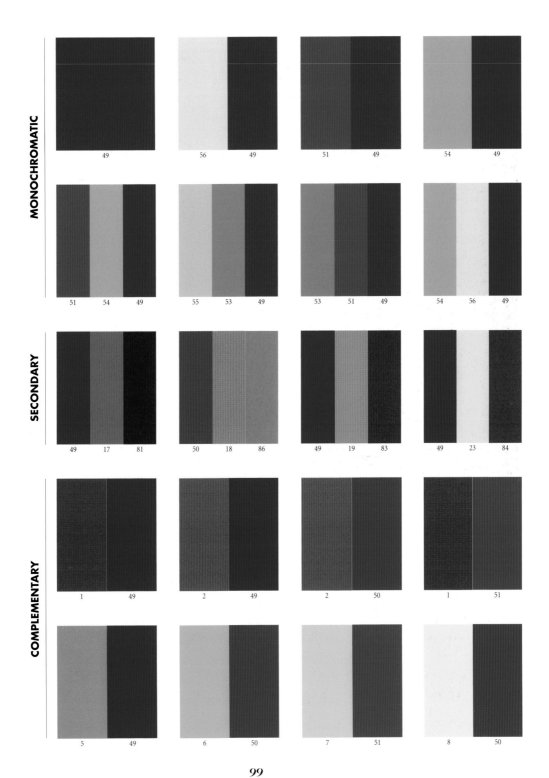

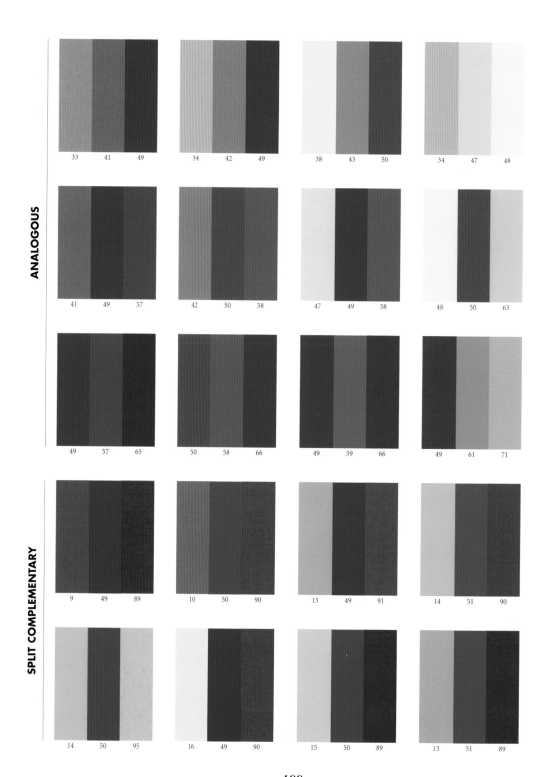

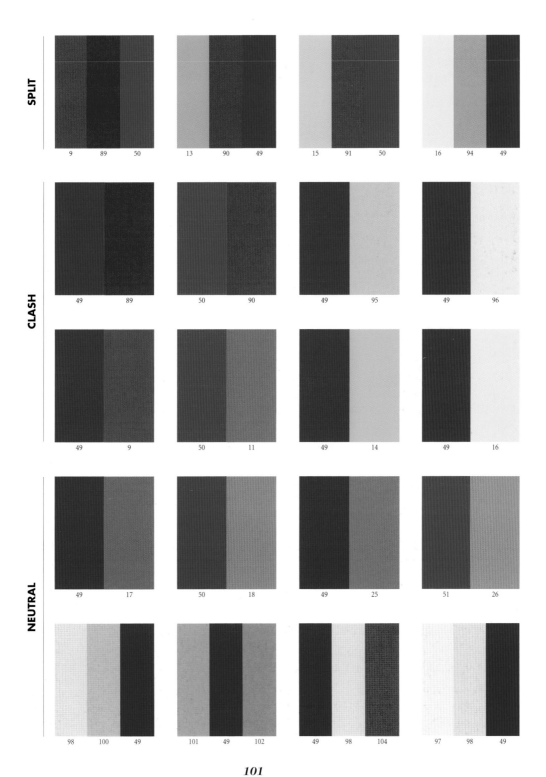

Refreshing

Color combinations that are considered refreshing usually include cool blue-green paired with its complement, red-orange. Blue-green, or teal, is fresh and invigorating. It is frequently used in its full hue to depict travel and leisure. Refreshing color combinations sparkle with lightness while providing a sense of soothing calm.

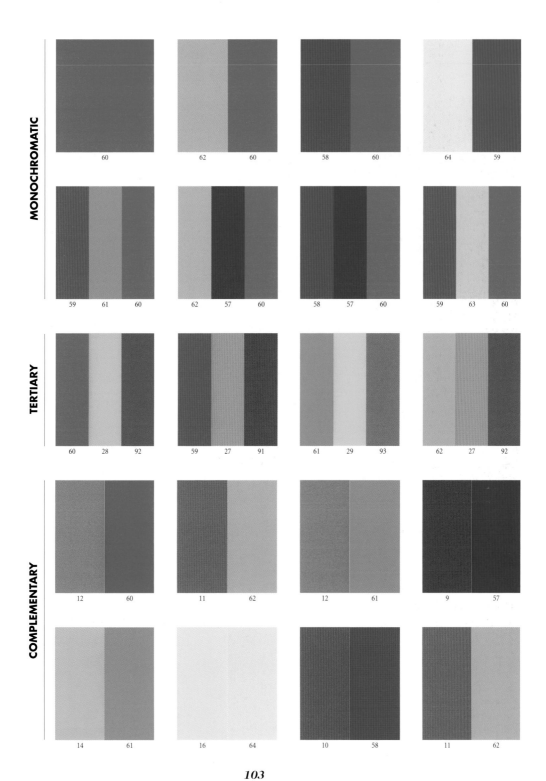

MONOCHROMATIC

60

62 60

58 60

64 59

59 61 60

62 57 60

58 57 60

59 63 60

TERTIARY

60 28 92

59 27 91

61 29 93

62 27 92

COMPLEMENTARY

12 60

11 62

12 61

9 57

14 61

16 64

10 58

11 62

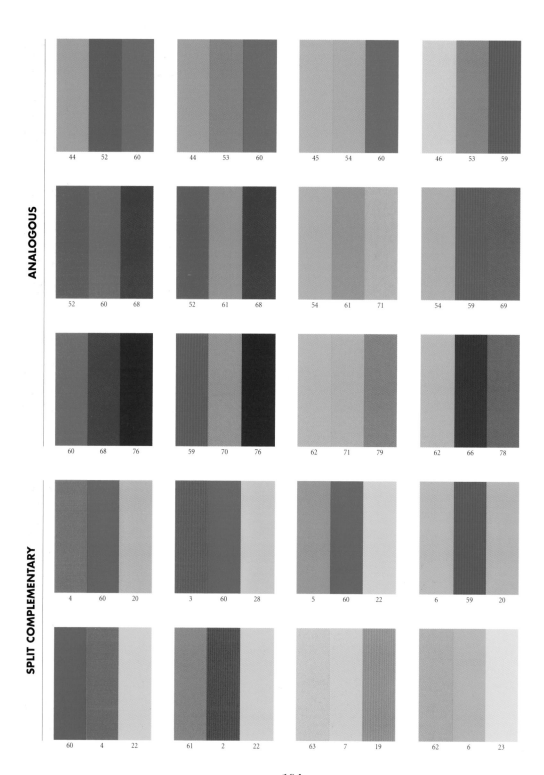

44	52	60
44	53	60
45	54	60
46	53	59

52	60	68
52	61	68
54	61	71
54	59	69

60	68	76
59	70	76
62	71	79
62	66	78

4	60	20
3	60	28
5	60	22
6	59	20

60	4	22
61	2	22
63	7	19
62	6	23

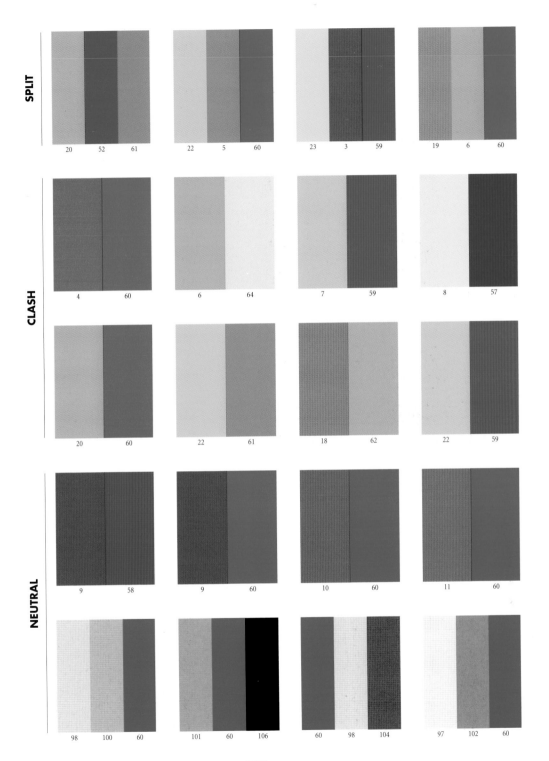

Tropical

Tropical hues on the color wheel always include turquoise. Blue-green is lightened to turquoise by the addition of white and is the warmest of the cool colors. Staying with the lightest tints of the blue-green family will increase the feeling and message of tranquility.

Using red-orange, the complement of turquoise, is perfect in any of these combinations. Like flowers in nature, these color schemes enhance any setting and create a serene and stress-free feeling.

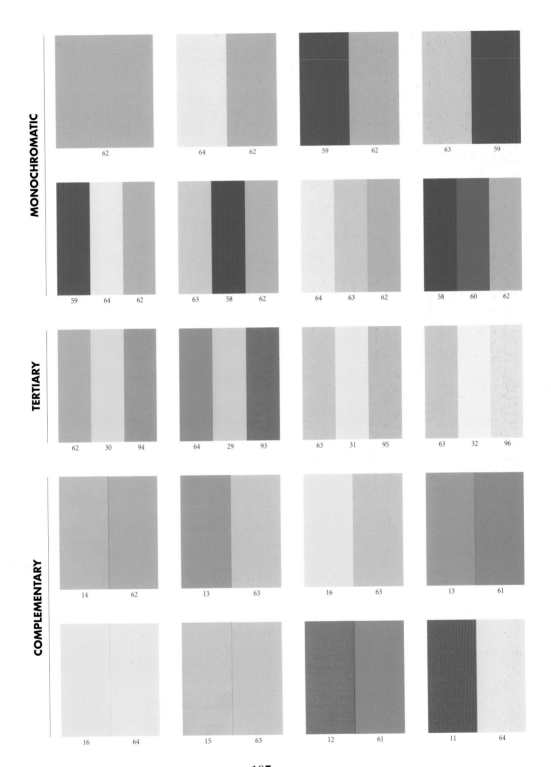

MONOCHROMATIC

62

64 62

59 62

63 59

59 64 62

63 58 62

64 63 62

58 60 62

TERTIARY

62 30 94

64 29 93

63 31 95

63 32 96

COMPLEMENTARY

14 62

13 63

16 63

13 61

16 64

15 63

12 61

11 64

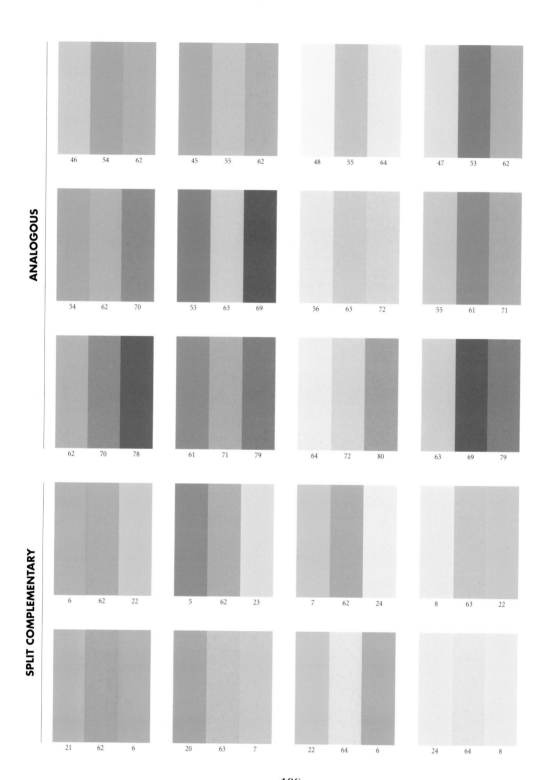

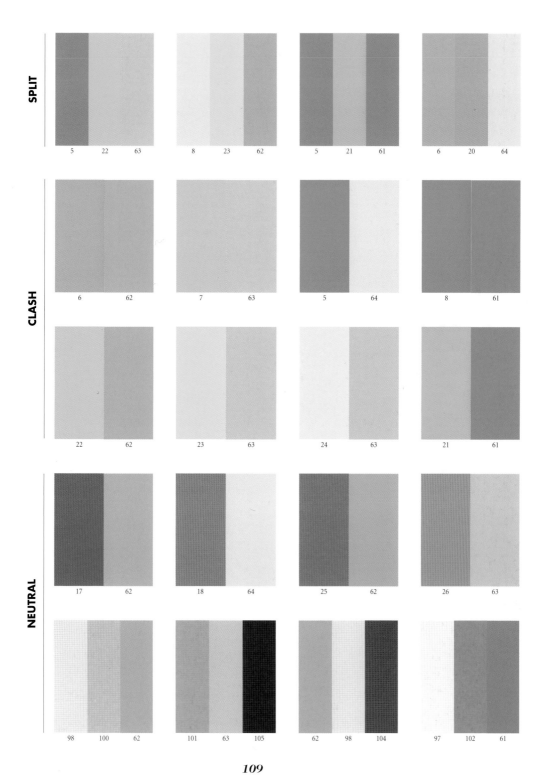

SPLIT

| 5 | 22 | 63 | | 8 | 23 | 62 | | 5 | 21 | 61 | | 6 | 20 | 64 |

CLASH

| 6 | 62 | | 7 | 63 | | 5 | 64 | | 8 | 61 |

| 22 | 62 | | 23 | 63 | | 24 | 63 | | 21 | 61 |

NEUTRAL

| 17 | 62 | | 18 | 64 | | 25 | 62 | | 26 | 63 |

| 98 | 100 | 62 | | 101 | 63 | 105 | | 62 | 98 | 104 | | 97 | 102 | 61 |

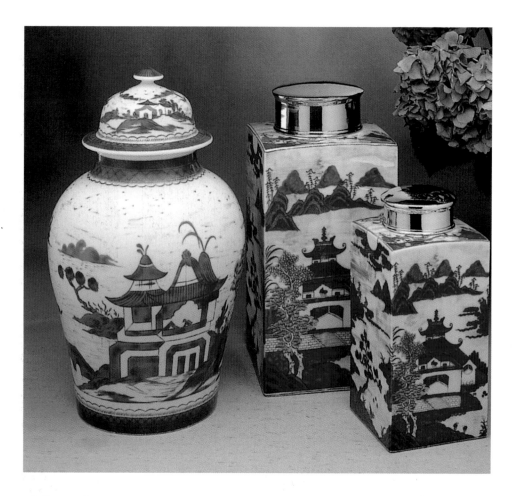

Classic

Classic color combinations are indicative of strength and authority. Intense royal blue is the centerpiece of any classic grouping of colors. It stands out, even when combined with other hues.

Classic combinations imply truth, responsibility, and trust. Because of its proximity to green, royal blue evokes a sense of continuity, stability, and strength, especially in combination with its split complement red-orange and yellow-orange.

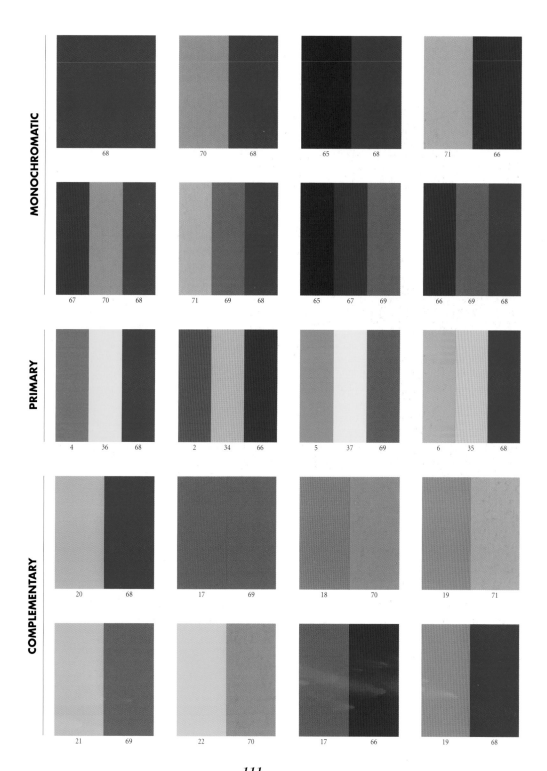

MONOCHROMATIC

PRIMARY

COMPLEMENTARY

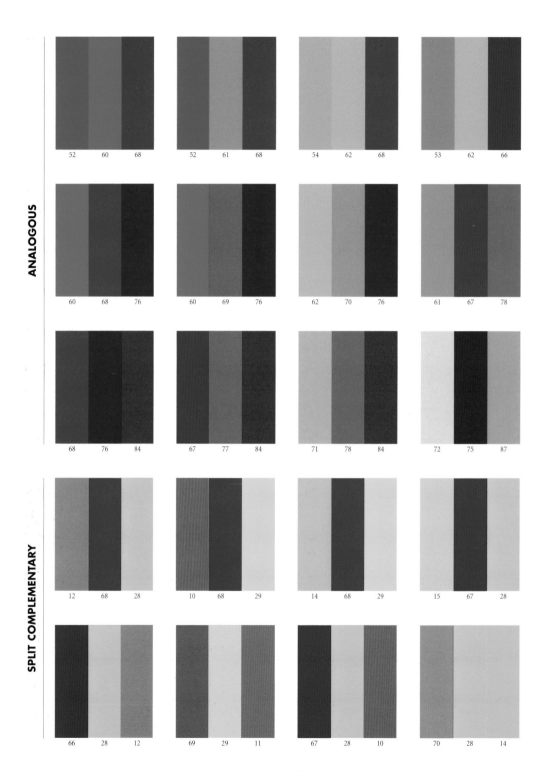

ANALOGOUS

52	60	68
52	61	68
54	62	68
53	62	66

60	68	76
60	69	76
62	70	76
61	67	78

68	76	84
67	77	84
71	78	84
72	75	87

SPLIT COMPLEMENTARY

12	68	28
10	68	29
14	68	29
15	67	28

66	28	12
69	29	11
67	28	10
70	28	14

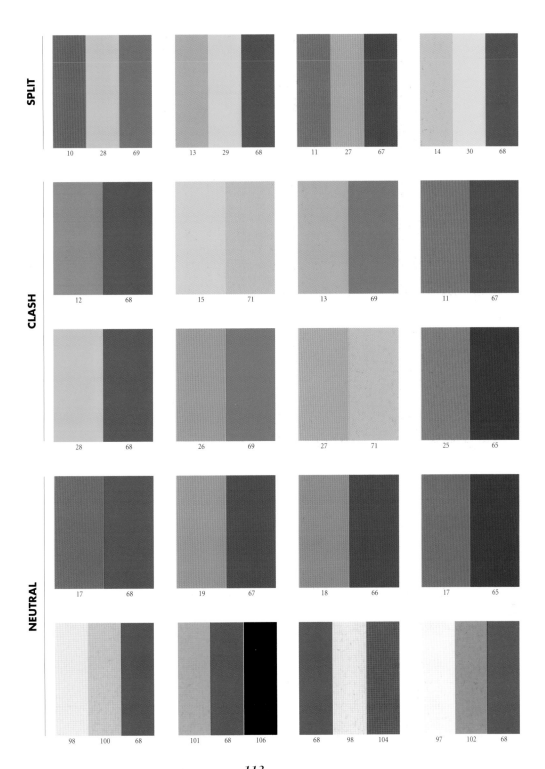

SPLIT

10 28 69
13 29 68
11 27 67
14 30 68

CLASH

12 68
15 71
13 69
11 67

28 68
26 69
27 71
25 65

NEUTRAL

17 68
19 67
18 66
17 65

98 100 68
101 68 106
68 98 104
97 102 68

Dependable

One of the most widely accepted hues is navy blue. Combinations using this color are interpreted as dependable and reliable. They also carry an undeniable message of authority. Police officers, naval officers, and court officers wear color combinations that include deep, secure navy blue in order to command authority through their appearance. When accented with red and gold, navy becomes less stern, but still communicates firmness and strength.

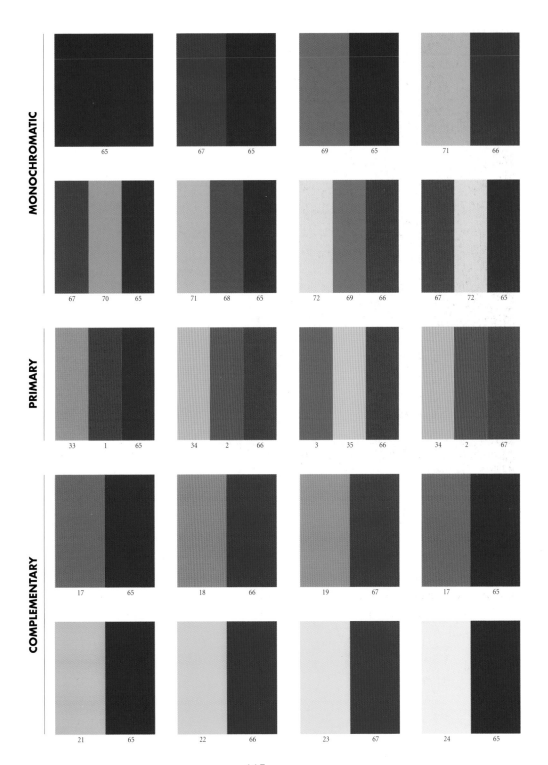

MONOCHROMATIC

65	
67	65
69	65
71	66

67	70	65
71	68	65
72	69	66
67	72	65

PRIMARY

33	1	65
34	2	66
3	35	66
34	2	67

COMPLEMENTARY

17	65
18	66
19	67
17	65

21	65
22	66
23	67
24	65

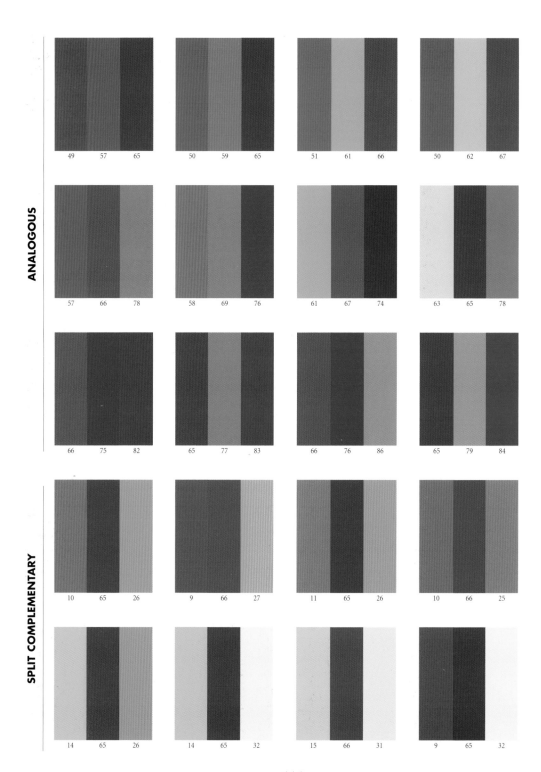

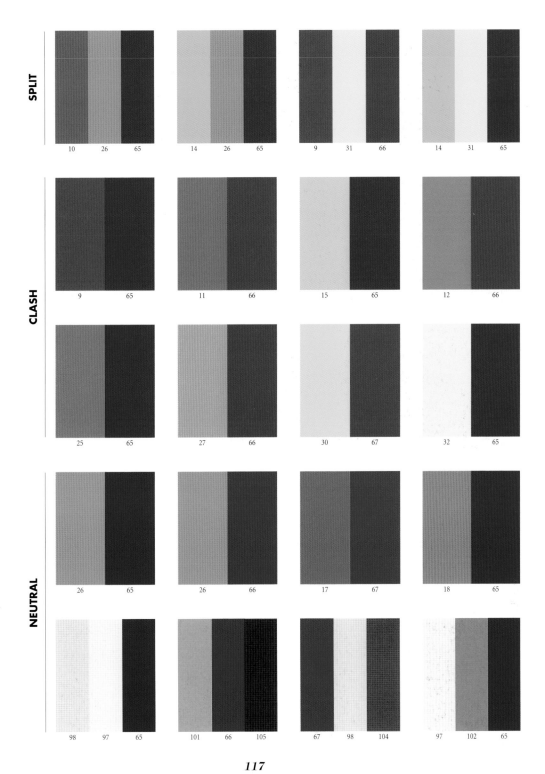

SPLIT

| 10 | 26 | 65 | | 14 | 26 | 65 | | 9 | 31 | 66 | | 14 | 31 | 65 |

CLASH

| 9 | 65 | | 11 | 66 | | 15 | 65 | | 12 | 66 |

| 25 | 65 | | 27 | 66 | | 30 | 67 | | 32 | 65 |

NEUTRAL

| 26 | 65 | | 26 | 66 | | 17 | 67 | | 18 | 65 |

| 98 | 97 | 65 | | 101 | 66 | 105 | | 67 | 98 | 104 | | 97 | 102 | 65 |

117
DEPENDABLE

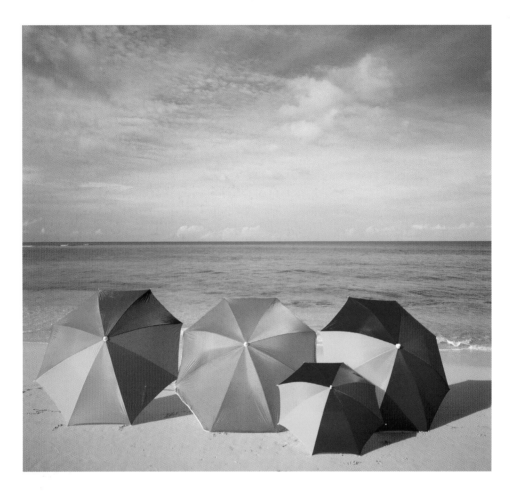

Calm

In any stressful environment, combining grayed or lightened tints of blue will produce a calming and restful effect. Lightened blue is at the center of color schemes that reassure and are considered truthful and direct.

Cool colors with tints can maintain a sense of well-being and peace. It is important that the complements and accents of these tranquil hues are similar in value, as hues which are too vivid can create unwanted tension.

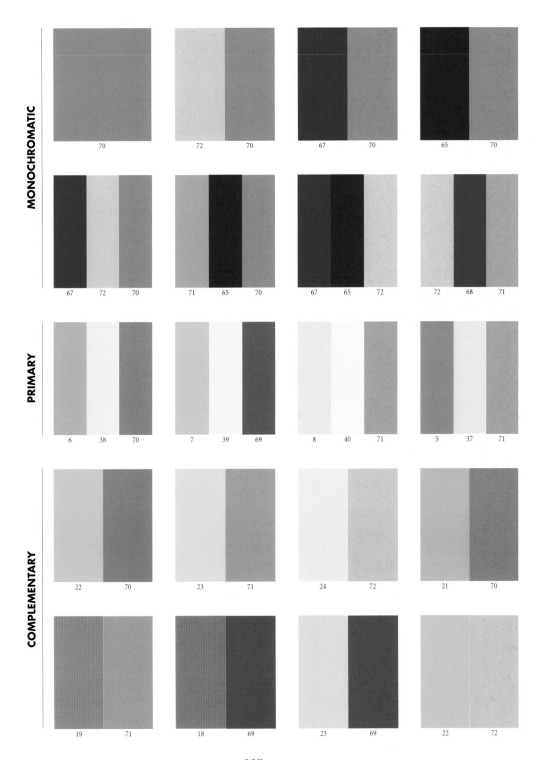

MONOCHROMATIC

PRIMARY

COMPLEMENTARY

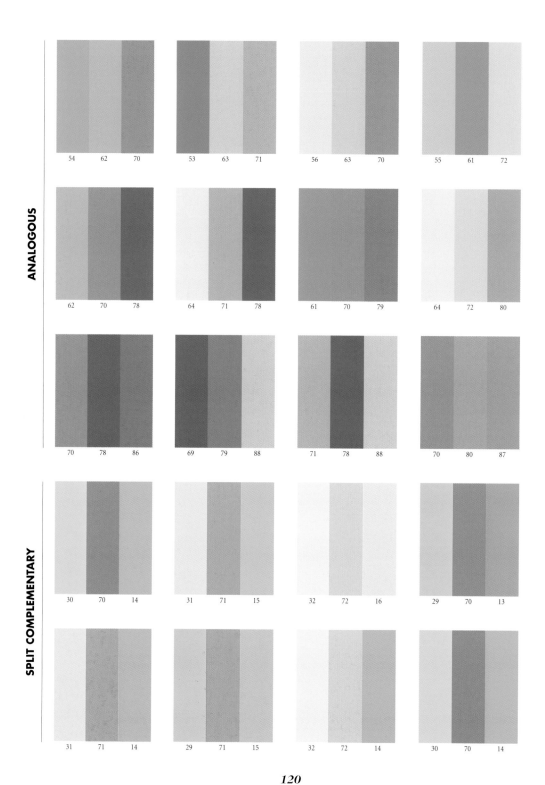

ANALOGOUS

54 62 70

53 63 71

56 63 70

55 61 72

62 70 78

64 71 78

61 70 79

64 72 80

70 78 86

69 79 88

71 78 88

70 80 87

SPLIT COMPLEMENTARY

30 70 14

31 71 15

32 72 16

29 70 13

31 71 14

29 71 15

32 72 14

30 70 14

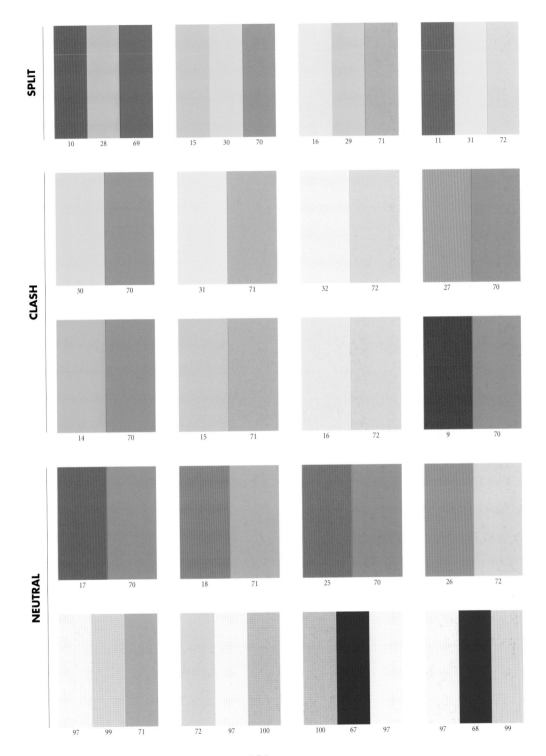

SPLIT

10 28 69 15 30 70 16 29 71 11 31 72

CLASH

30 70 31 71 32 72 27 70

14 70 15 71 16 72 9 70

NEUTRAL

17 70 18 71 25 70 26 72

97 99 71 72 97 100 100 67 97 97 68 99

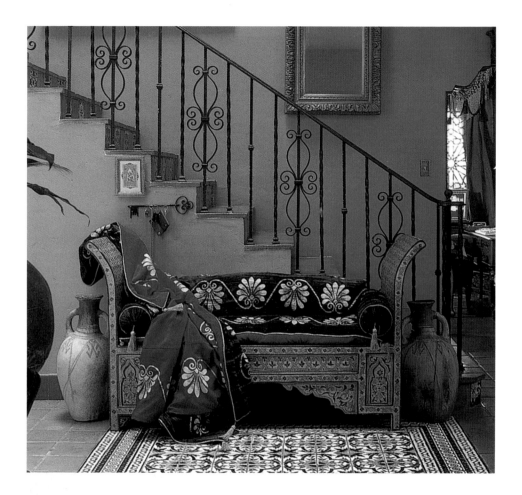

Regal

The fullness of blue combined with the power of red creates blue-violet. It is the darkest hue on the color wheel and contains no black to diminish its innate power.

Combinations using this color symbolize authority and regal inspiration. Likened to the deepest blue-black plums of summer, blue-violet combined with its complement, yellow-orange, creates a most striking color scheme. This lush combination suggests royalty and is seldom used outside a daunting environment.

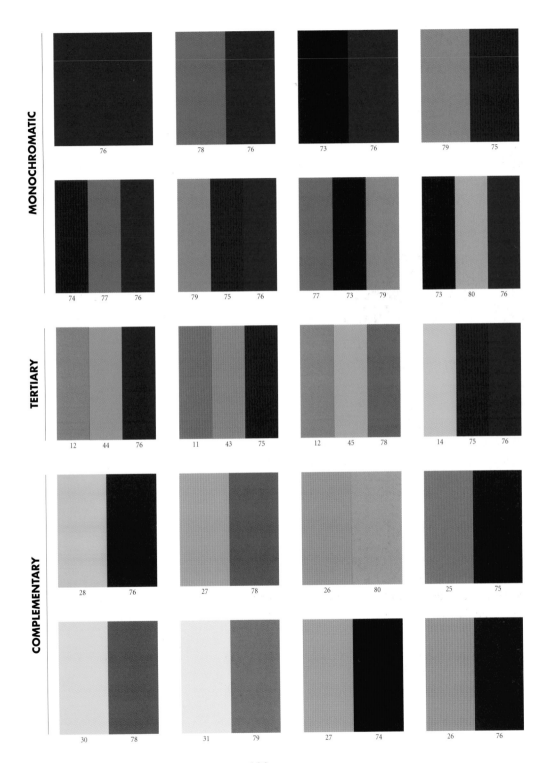

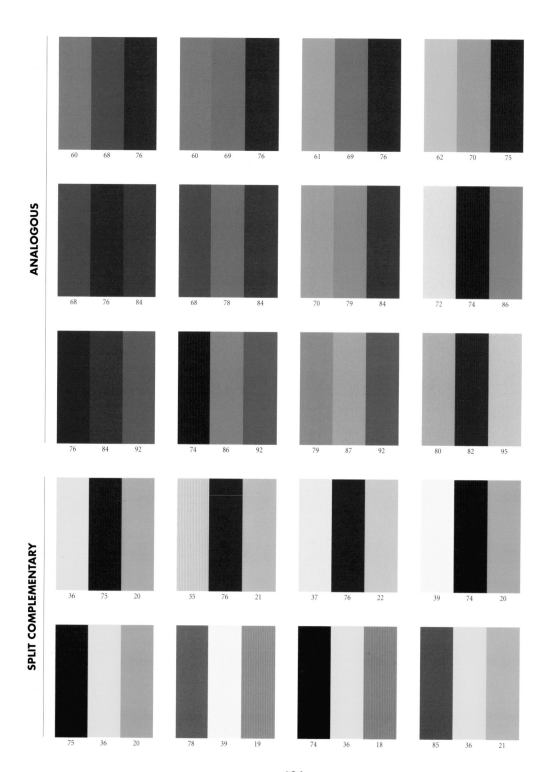

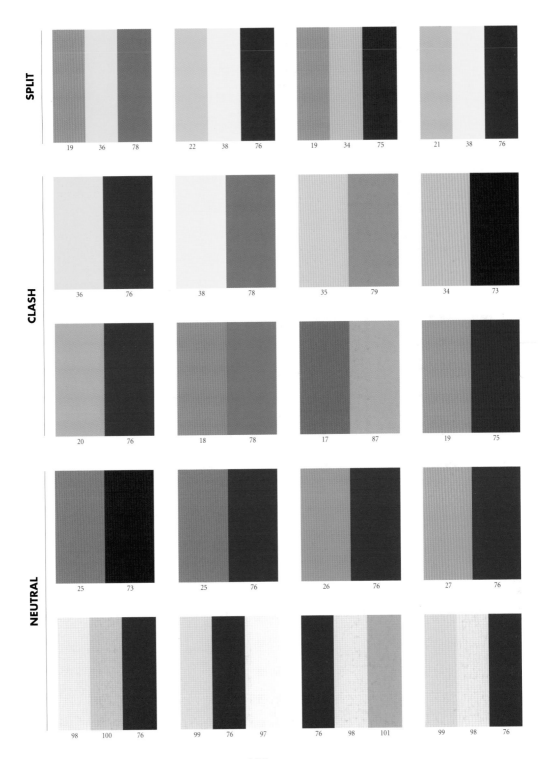

SPLIT

19	36	78
22	38	76
19	34	75
21	38	76

CLASH

36	76
38	78
35	79
34	73

20	76
18	78
17	87
19	75

NEUTRAL

25	73
25	76
26	76
27	76

98	100	76
99	76	97
76	98	101
99	98	76

Magical

Elements of surprise and magic are often associated with violet. By itself, violet conveys its own unpredictable personality. With its secondary partners, orange and green, violet in any tint or shade becomes part of an exciting team, which is slightly offbeat.

When used with chartreuse and yellow-orange, it is whimsical and clashing, even loud. In combination with its true complement yellow, violet has spectral balance and can be enjoyed for extended periods of time. In fashion, it is considered an immature color and is used to bridge the gap between child and adult.

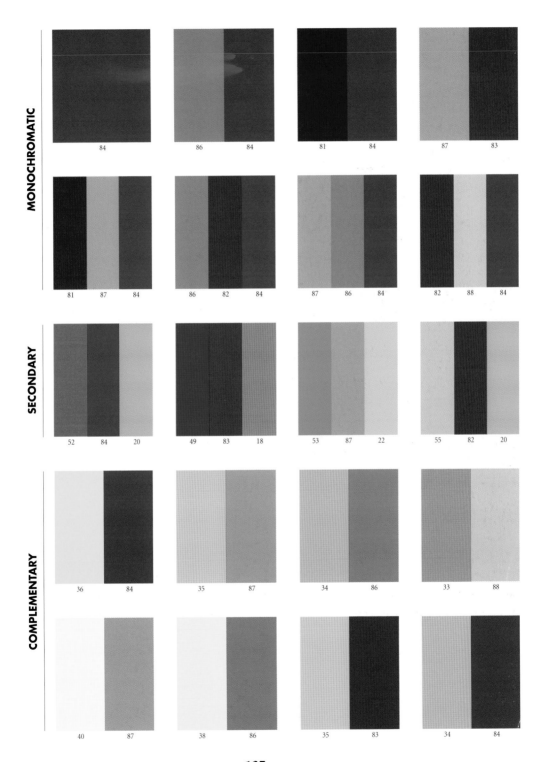

MONOCHROMATIC

84

86 84

81 84

87 83

81 87 84

86 82 84

87 86 84

82 88 84

SECONDARY

52 84 20

49 83 18

53 87 22

55 82 20

COMPLEMENTARY

36 84

35 87

34 86

33 88

40 87

38 86

35 83

34 84

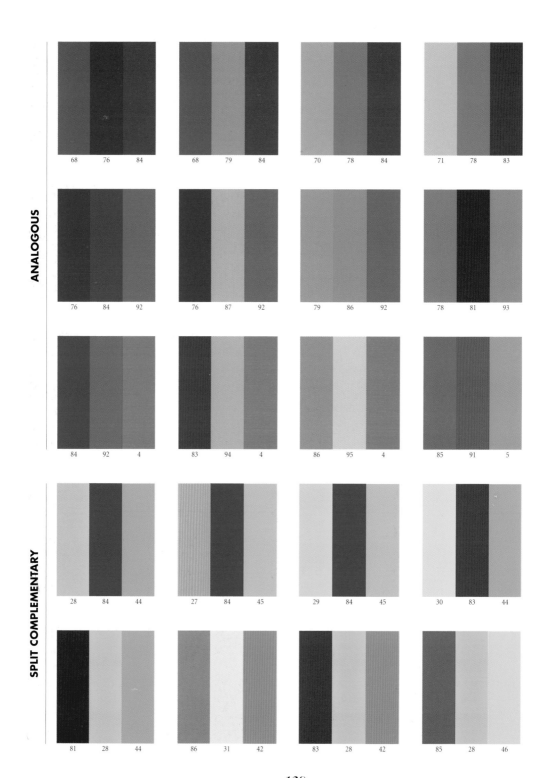

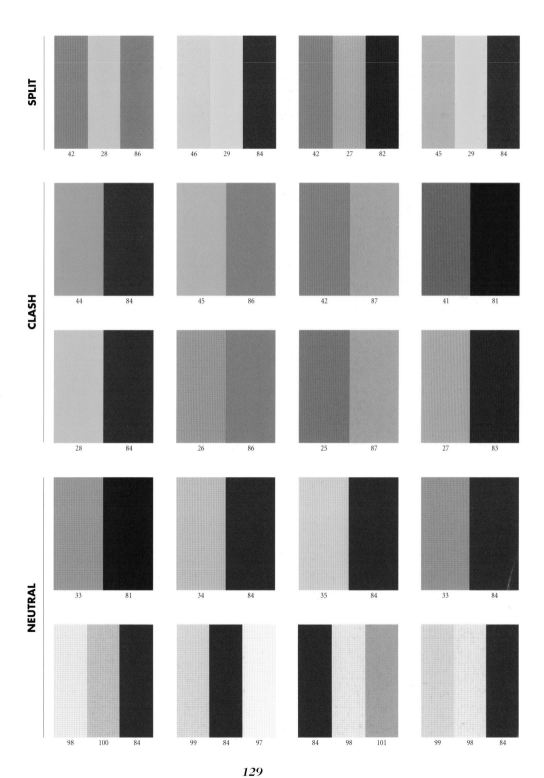

SPLIT

42 28 86 46 29 84 42 27 82 45 29 84

CLASH

44 84 45 86 42 87 41 81

28 84 26 86 25 87 27 83

NEUTRAL

33 81 34 84 35 84 33 84

98 100 84 99 84 97 84 98 101 99 98 84

Nostalgic

Color combinations using lavender are often thought of as nostalgic. They are reminiscent of the Victorian era and can remind us of dreamy moments, poetry, and romantic ideals. More delicate and less passionate than pink, lavender has red and blue in its violet makeup. When combined with other pastels, lavender is the prominent hue, even with its muted accents.

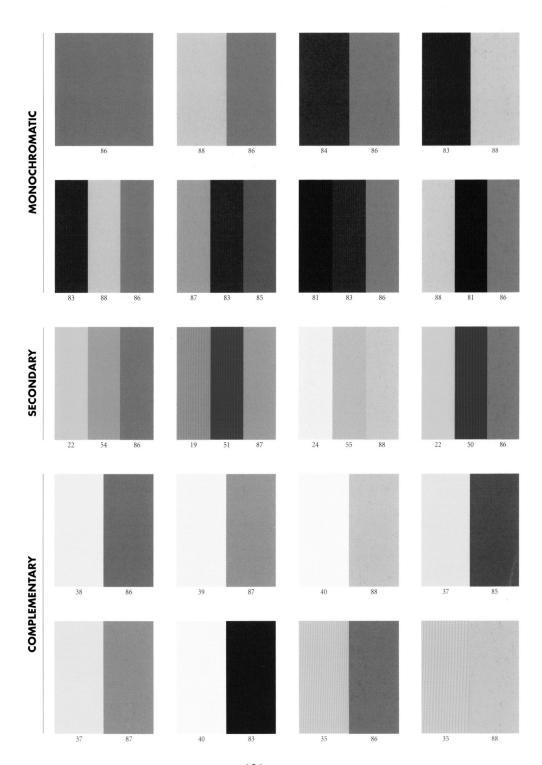

MONOCHROMATIC

86

88 86

84 86

83 88

83 88 86

87 83 85

81 83 86

88 81 86

SECONDARY

22 54 86

19 51 87

24 55 88

22 50 86

COMPLEMENTARY

38 86

39 87

40 88

37 85

37 87

40 83

35 86

35 88

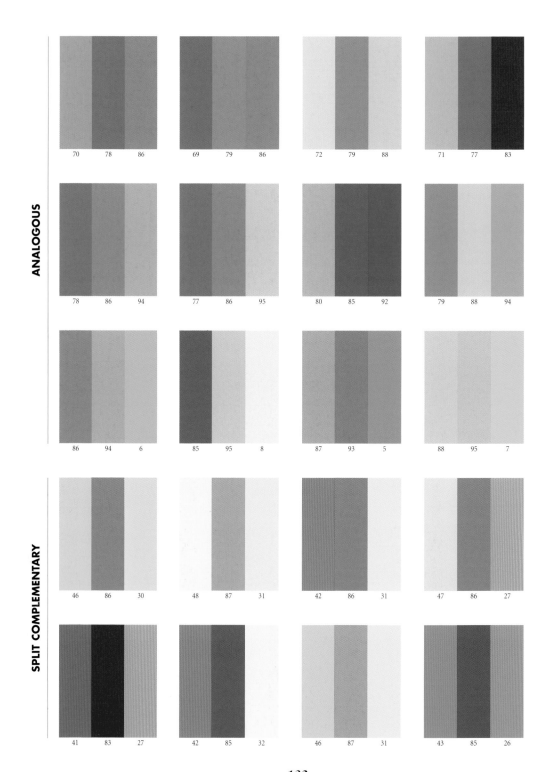

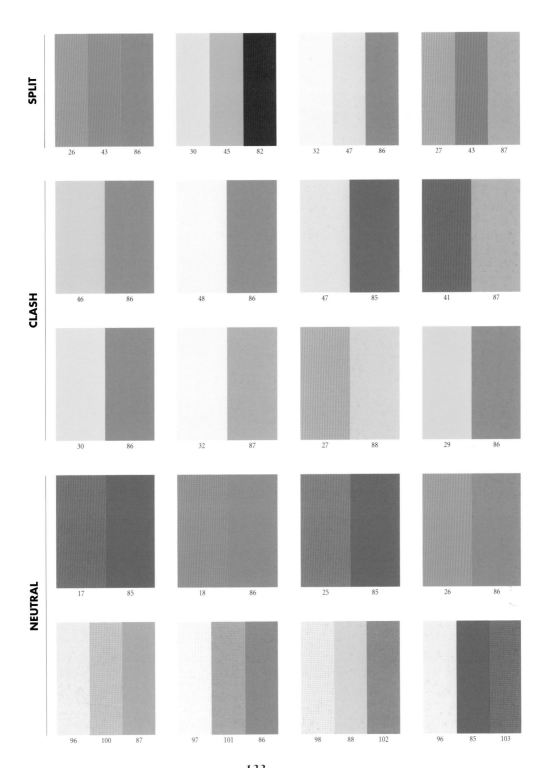

SPLIT

26 43 86 30 45 82 32 47 86 27 43 87

CLASH

46 86 48 86 47 85 41 87

30 86 32 87 27 88 29 86

NEUTRAL

17 85 18 86 25 85 26 86

96 100 87 97 101 86 98 88 102 96 85 103

133
NOSTALGIC

Energetic

Color combinations that are energetic often contain red-violet, also known as fuchsia. It always sends an unmistakable message of activity. Fuchsia, or magenta, has such an exuberant personality that in order to be workable it is often combined with its complementary hue, chartreuse.

A clash combination using fuchsia and yellow or green will be exciting for the moment, but will invariably limit the overall effect of the combination and lessen its workability. Yellow-green, when paired with fuchsia or magenta, heightens the enthusiastic personality of this energetic color.

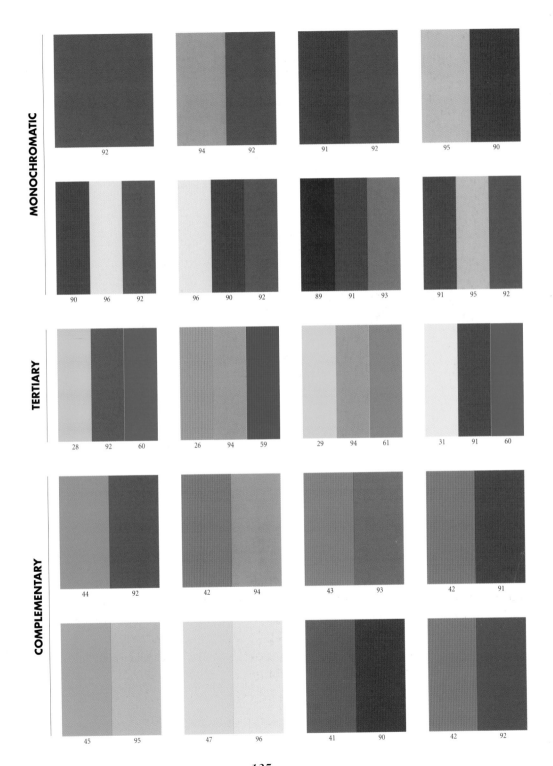

MONOCHROMATIC

92

94 92

91 92

95 90

90 96 92

96 90 92

89 91 93

91 95 92

TERTIARY

28 92 60

26 94 59

29 94 61

31 91 60

COMPLEMENTARY

44 92

42 94

43 93

42 91

45 95

47 96

41 90

42 92

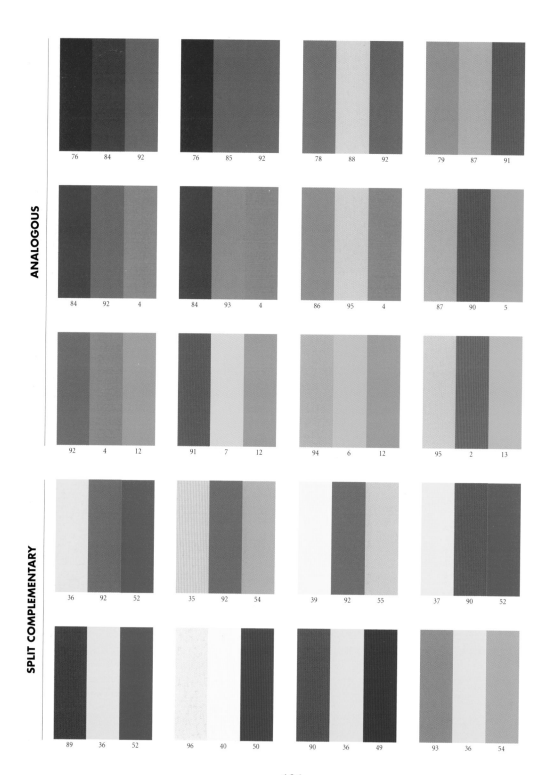

ANALOGOUS

76	84	92
76	85	92
78	88	92
79	87	91

84	92	4
84	93	4
86	95	4
87	90	5

92	4	12
91	7	12
94	6	12
95	2	13

SPLIT COMPLEMENTARY

36	92	52
35	92	54
39	92	55
37	90	52

89	36	52
96	40	50
90	36	49
93	36	54

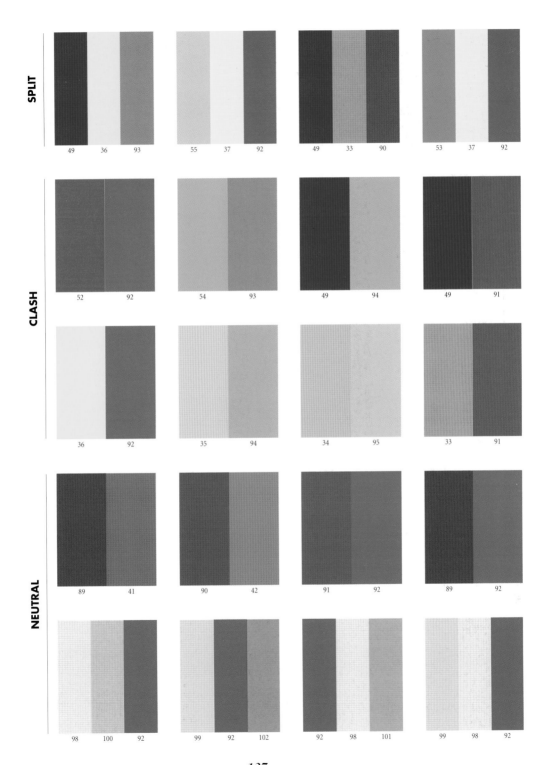

SPLIT

49 36 93 55 37 92 49 33 90 53 37 92

CLASH

52 92 54 93 49 94 49 91

36 92 35 94 34 95 33 91

NEUTRAL

89 41 90 42 91 92 89 92

98 100 92 99 92 102 92 98 101 99 98 92

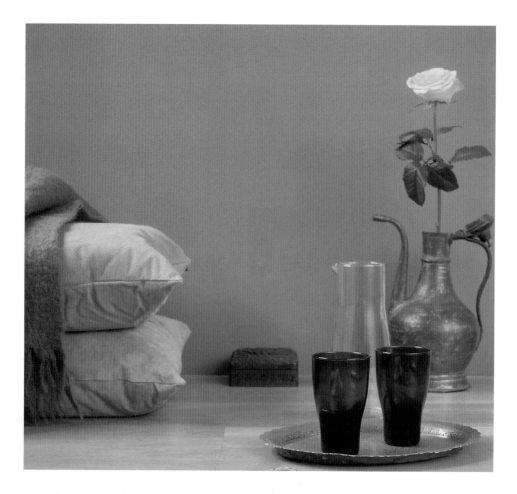

Subdued

Unlike an energetic color scheme, a subdued or grayed scheme has little contrast. Mauve, a blend of magenta, gray, and white, is a diminished color. The addition of minimal gray and white to any brilliant hue results in subdued and delicate variations, including grayed blues and grayed greens. Mauve combined with other tints and shades appears to be understated and dull. A spark of color in the form of its complement, or a more vivid tone of the original hue, must be added to bring these mellow hues back to life. To maintain the subdued nature of similar colors, shades should be used sparingly.

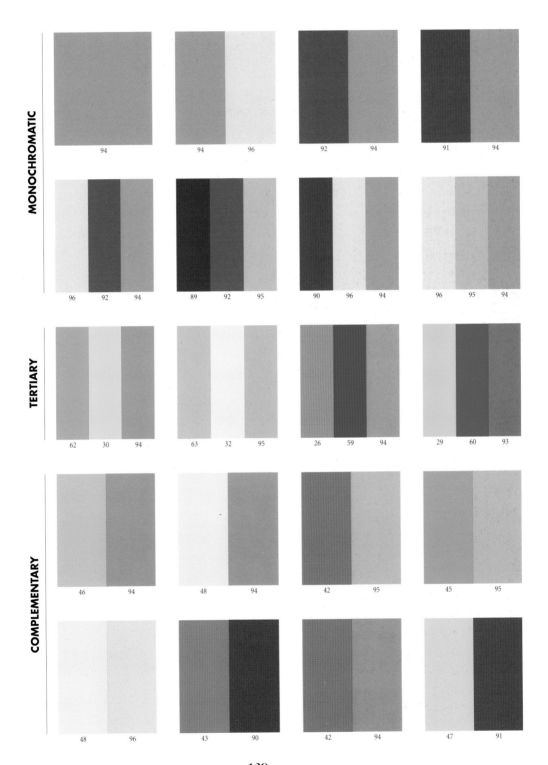

MONOCHROMATIC

94

94 96

92 94

91 94

96 92 94

89 92 95

90 96 94

96 95 94

TERTIARY

62 30 94

63 32 95

26 59 94

29 60 93

COMPLEMENTARY

46 94

48 94

42 95

45 95

48 96

43 90

42 94

47 91

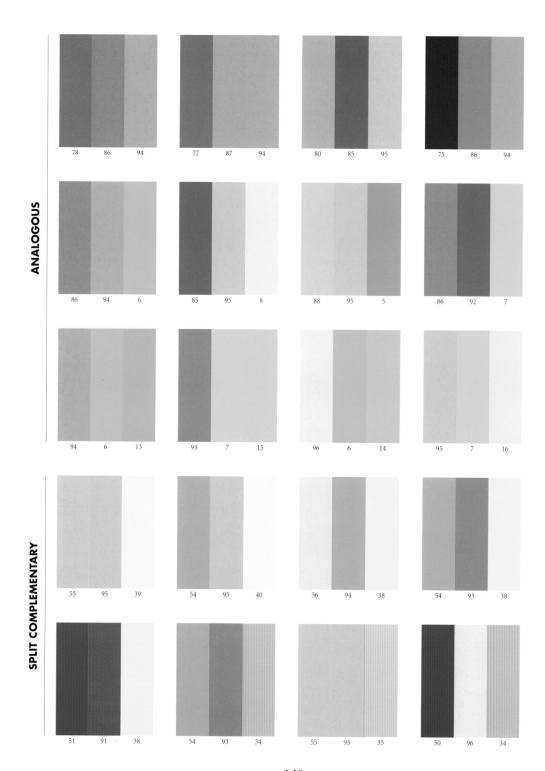

ANALOGOUS

SPLIT COMPLEMENTARY

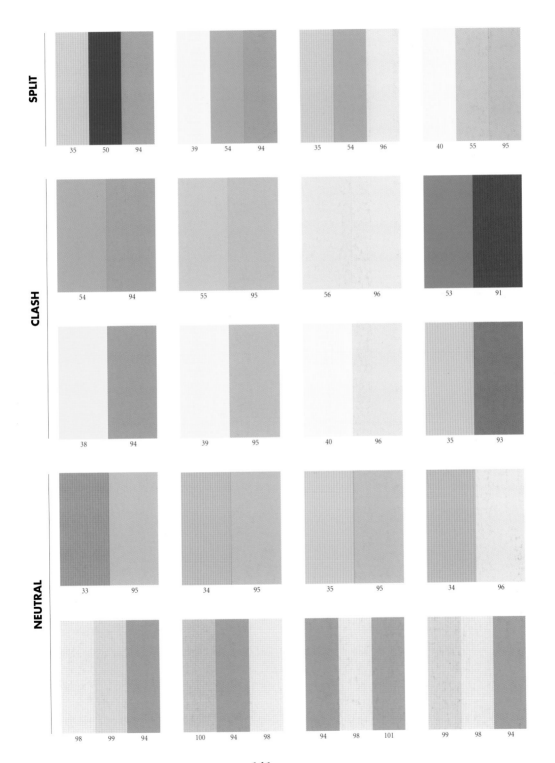

SPLIT

35 50 94
39 54 94
35 54 96
40 55 95

CLASH

54 94
55 95
56 96
53 91

38 94
39 95
40 96
35 93

NEUTRAL

33 95
34 95
35 95
34 96

98 99 94
100 94 98
94 98 101
99 98 94

Professional

In the world of the business professional, color is evaluated with scrutiny. In fashion, the word "professional" has come to mean grays and tonal blacks because these colors lack personal characteristics and are truly neutral. Warmed grays, however, are perfect backgrounds for brilliant hues such as red, teal, or orange. Schemes based on a chromatic gray combined with vivid accents become accented neutrals.

Gray is unexciting but practical. It sends a sober message, with a minimum of humor.

Pure

White is not merely the absence of color, but also a hue that designates purity, innocence, and class. It is hopeful, suggesting goodness and truth. Remember, the good guys always wore the white hats, and a little white lie isn't so bad after all.

Cool whites echo an icy cleanliness, especially when combined with pale blues and spa greens, while warmer tones of white suggest tranquility and refinement. Though boring when used alone, white takes on a quiet, moneyed appeal in tonal combinations with the softest beiges and gives the eye a place to rest when combined with energizing brights.

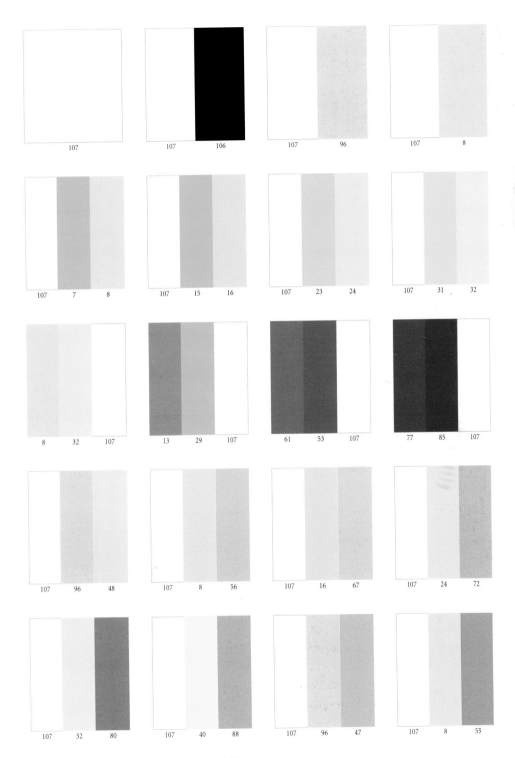

107

107 106

107 96

107 8

107 7 8

107 15 16

107 23 24

107 31 32

8 32 107

13 29 107

61 53 107

77 85 107

107 96 48

107 8 56

107 16 67

107 24 72

107 32 80

107 40 88

107 96 47

107 8 55

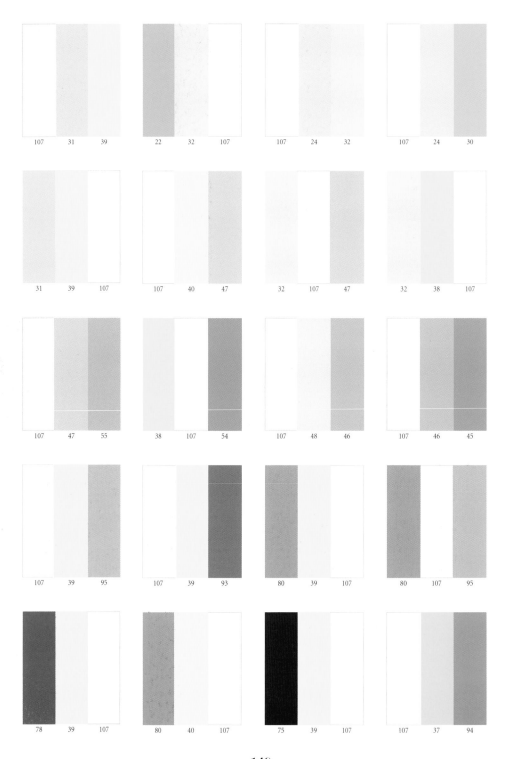

107 31 39 22 32 107 107 24 32 107 24 30

31 39 107 107 40 47 32 107 47 32 38 107

107 47 55 38 107 54 107 48 46 107 46 45

107 39 95 107 39 93 80 39 107 80 107 95

78 39 107 80 40 107 75 39 107 107 37 94

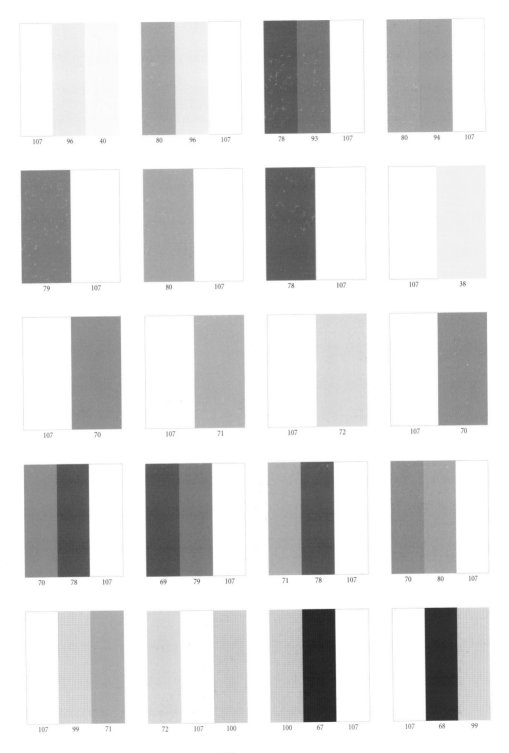

107 96 40 80 96 107 78 93 107 80 94 107

79 107 80 107 78 107 107 38

107 70 107 71 107 72 107 70

70 78 107 69 79 107 71 78 107 70 80 107

107 99 71 72 107 100 100 67 107 107 68 99

Graphic

The color combination of black and white is classic and dramatic at the same time—think newspaper headlines, piano keys, and tuxedoes. In decorating, black-and-white tiles add a touch of elegance to a hallway, while in fashion nothing is more cosmopolitan than basic black with pearls.

When combined with a single bright, such as red or hot pink, black and white is graphic, a bit shocking and decidedly memorable.

Black can be mysterious, even seductive, like black cats and film noir. Because it is so powerful, even a fine line of black boldly separates colors in graphic design.

106

106　105　103

103　104　106

106　107　98

106　1　7

106　9　15

106　17　23

106　25　31

106　33　37

106　41　45

106　49　53

106　57　61

106　65　69

106　73　77

106　81　85

106　89　93

106　4

106　20

106　36

106　52

| 106 | 4 | 52 | | 106 | 12 | 60 | | 106 | 20 | 68 | | 106 | 28 | 76 |

| 106 | 36 | 84 | | 106 | 44 | 92 | | 106 | 12 | 68 | | 106 | 12 | 52 |

| 106 | 20 | 76 | | 106 | 20 | 60 | | 106 | 28 | 84 | | 106 | 28 | 68 |

| 106 | 36 | 92 | | 106 | 36 | 76 | | 106 | 44 | 84 | | 106 | 44 | 4 |

| 106 | 52 | 92 | | 106 | 60 | 4 | | 106 | 60 | 20 | | 106 | 68 | 12 |

| 106 | 68 | 92 | | 106 | 107 | 76 | | 106 | 107 | 84 | | 106 | 107 | 92 |

| 106 | 107 | 4 | | 106 | 107 | 12 | | 106 | 107 | 20 | | 106 | 107 | 28 |

| 106 | 96 | | 106 | 88 | | 106 | 80 | | 106 | 72 |

| 106 | 64 | | 106 | 56 | | 106 | 47 | | 106 | 48 |

| 106 | 40 | | 106 | 32 | | 106 | 24 | | 106 | 16 |

The Psychology of Color

Believe it or not, wearing certain colors can help you get a raise, win an argument, and encourage friends to spill the latest gossip. Colors in your home have the ability to relax you, encourage or discourage conversation, and even give you insomnia. And hues on packaging send subliminal messages that the enclosed product is healthy, expensive, or dangerous.

Why? Because of the psychology of color, which refers to the strong emotional reactions we all have to colors. Research studies have proven that our responses are partly physiological, based on the effects colors have on our eyes and nervous system, and partly influenced by our environment and life experiences.

Starting with the science at its simplest, the retina focuses on colors as rays of light which have varying lengths and degrees of refraction, reflection, and absorption, depending on the hue. The eye's perception of each color triggers instantaneous reactions in the brain and autonomic nervous system.

For example, hot colors—such as red, orange, and yellow—have the longest wavelengths, requiring energy to view them. That's why those colors seem to pop out at you. They also stimulate the brain and raise pulse and respiration rates.

In contrast, cool colors—such as blues and greens—have the shortest wavelengths and easily enter the eye. That produces a calming and soothing effect while actually slowing the metabolism.

In addition to the involuntary reactions we have to color, learned responses are equally important. We're taught that pink is for baby girls and blue is for boys, white bridal gowns signify purity and innocence, and red traffic signs mean stop or danger.

The color of your clothes can also speak volumes. Would you be more confrontational with a customer-service representative who is dressed in white or black? Would you feel safer with a doctor wearing a navy tie or a bright orange one? Who would you choose as a financial advisor, a woman in a blue suit or one in hot pink?

The colors we wear can be reassuring, unsettling, or energizing. While there are no "good" or "bad" colors, we can

make distinct choices to help us communicate more effectively. That is true not only in fashion, but also in home decor, advertising, graphics, product design, and retail environments.

For example, are guests yawning at your dinner parties? It may not be the company if your dining room walls are painted lavender, a color that encourages daydreaming and dozing.

Looking for more than a cost-of-living raise at work? Wear an article of red clothing several times a week prior to your year-end review. As the most memorable and eye-catching of all colors, red will get you noticed and your boss will be much more likely to remember your ideas.

Since color unconsciously influences people every day, there's a great advantage to understanding how and why these reactions occur. What follows is a detailed explanation of the physical responses we have to each color, along with the most common psychological associations. Also included are suggestions on how best to use this information in a variety of artistic, business, and lifestyle applications.

RED

When a matador waves a red cape in the ring, he is playing to the crowd as much as the bull. Bulls are actually color-blind and respond only to the movement of the cape; the audience, however, fully appreciates the energy of vibrant red. The color says danger, excitement, passion, strength, aggression, and success. That's not just an emotional reaction, but a physiological one as well.

Red is a literal shock to the system, grabbing your attention and requiring an effort to view. Staring at red will raise your blood pressure and make your pulse race. Ever wonder why so many fast food restaurants are painted red? The color activates your salivary glands, making you hungry while also tiring your eyes, which encourages you to eat a lot and leave quickly. And since red is the first color we notice just try to drive by a roadside McDonald's without your child seeing it.Because of its powerful effect on your autonomic nervous system, red can also make you jumpy and restless. Gambling casinos found that people place larger and riskier bets under red lights, so they're often used in high-stakes areas—that's something to think about on your next trip to Las Vegas. At the same time, the color stimulates people to make quick decisions, which is why it's a popular choice for "Buy Now" buttons on retail websites.

Red also telegraphs energy and courage, giving one a sense of power to get things done. That's why politicians often wear red ties, a particular favorite in presidential debates. As a bonus, red is the most memorable of all colors.

Clearly, red evokes intense, strong emotions—passion among them. After all, it's the favorite color for valentines and appropriately named "red light" districts. Women in red are often seen as flirtatious, extroverted, and playful. Think about it. The moment a woman puts on a red dress, the color will make her mate salivate and get his heart pumping faster.

In China, red represents good luck and is worn by brides and used in "red egg" ceremonies to bless newborn babies. Feng shui practitioners suggest using the power of red to expel bad *ch'i*, or energy, from the house. But in decorating, red comes with a warning: Use

it only in rooms where you want to encourage activity and lively conversation, such as a living or dining room. (If you do put it in your dining room, be prepared for people to eat twice as much.)

Red is also a great choice for "passing through" spaces where you don't spend a lot of time, such as hallways, lobbies, or guest bathrooms. In a child's room, the color can actually cause insomnia.

Red's high visibility makes it ideal for catching your eye in advertising and safety products, from Campbell soup cans to fire extinguishers and exit signs. The dynamism of red also makes it the most commonly used color in national flags.

COLOR PSYCH 101

- True red is the most vibrant, compelling color in the spectrum, expressing excitement, speed, power, joy, danger, and passion.
- Red attracts immediate attention and brings objects or images to the foreground.
- Red makes people feel warm. Coffee will seem hotter in a red cup than in a blue one.
- Red is the first color you lose sight of at twilight and is not well seen at a great distance.
- Barn, claret, and crimson reds are considered regal, exclusive, and strong and have great appeal for men.

YELLOW

There's a good reason the smiley face icon is yellow. As the color of the sun, yellow quite literally lights up our lives. Psychologically it is the happiest color in the spectrum, transmitting feelings of optimism, joy, and spontaneity. Think of the term "sunny disposition."

Association with the sun also gives yellow an enlightened aura, signifying wisdom, intellect, and imagination. That feeling is supported by science, as yellow quickly registers with the brain, stimulating the nervous system and the mind. Appropriately, it is said to have been the favorite color of Chinese philosopher Confucius.

Yellow is a color you can't ignore—it visually pops out at you. Next time you're in the supermarket, check out the cereal aisle. The Cheerios boxes will seem to be farther forward than the other products on the same shelf. And you certainly can't miss yellow taxicabs in traffic.

Yellow's high visibility also promotes quick, clear thinking, according to legendary color theorist Faber Birren, who focused on the functional use of hues in everyday life. Birren was responsible for the creation of the Yellow Pages in the 1950s to relieve the on-the-job monotony for telephone operators.

Research from Pantone later confirmed Birren's theory, proving that a yellow background with black type is the most legible combination for printed material and the most conducive to memory retention. No wonder it's used on legal pads and traffic caution signs.

Yellow also adds vitality to other colors, making hot hues seem even more brilliant and bringing cool colors to life. It's therefore a consistent favorite in the home, filling any room with warmth, good cheer, and light. Most popular in kitchens and dining rooms, yellow also provides an appetizing backdrop for food.

However, a little goes a long way. In small doses it encourages lively conversation and happy times, but prolonged exposure to bright lemon can provoke too much mental stimulation and create anxiety. It has been reported that couples have more spats in yellow kitchens and the color can make babies cry. Pale buttercup is a safer choice in the home.

Yellow sends out other mixed messages as well. References to a coward being "yellow" started in tenth-century France, where the doors of traitors were painted that color. But that negative association has been replaced in more recent times with overtones of patriotism, as Americans tie yellow ribbons around trees in support of their fighting troops.

In many countries yellow suggests success, prosperity, and power. In Japan, it means grace and nobility, an association that goes back to ancient warriors who wore yellow chrysanthemums into battle as a pledge of courage.

ORANGE

Falling asleep at your desk? Pick up an orange—not just to eat, but to look at. The color encourages oxygen intake to the brain to get those creative juices flowing. And since orange also stimulates the appetite and aids in digestion, you'll want to pop that fruit in your mouth before long.

Orange is a mixture of red and yellow, borrowing characteristics from both colors. It has the energy and vitality of red and the happy, friendly qualities of yellow. That makes orange an audacious, energizing color suggesting fun and spontaneity.

Bright orange is a surefire attention getter used effectively by construction workers and crossing guards as a warning. It represents good value as well, making it a favorite for sale signs in store windows.

In more muted tones, like the colors of pumpkins and turning leaves, orange is a reminder of autumn and the harvest, with their warm, pleasing associations. Burnt orange and persimmon are also easier on the eye and have a sophisticated appeal that can be both elegant and exotic. Think Hermès boxes and sun-baked ceramics.

COLOR PSYCH 101

- Orange is a stimulating, energizing color that appears friendly, outgoing, cheerful, and adventurous.
- Bright orange has very high visibility, making it ideal for warning signals or grabbing attention, even when used in small amounts.
- Easier on the eye, autumnal and spicy oranges are warm, exotic, and appetizing, while peach tones are most flattering to the skin.
- People who wear orange are thought to be creative, enthusiastic, and fun to be with, but possibly also a bit irresponsible.
- Because of its playful, active qualities, orange is a favorite of children, teens, and athletes.

Terra-cottas are especially popular in the packaging of ethnic foods and gourmet products, conveying the feel of travel to foreign places and an assurance of freshness and quality.

Intense orange is best used sparingly in home decoration. As one interior designer suggested, think of it as a punctuation mark. When used judiciously, though, orange can be unexpected and luxurious, warming a room like a fire's glow.

This vibrant hue can be used effectively in advertising and product packaging as well, since it creates the optical illusion of bringing objects to the foreground and commands attention even when used in small amounts. Orange also says fresh, healthy, and juicy, making it a favorite for table settings and kitchen accessories.

Peach is a particularly pleasing color in the home. It not only radiates warmth and good feelings, but also reflects a flattering light on one's skin, giving your face a rosy glow. And it's a lovely color to look at both during the day and under artificial evening light. Many expensive restaurants paint their walls pale peach for those very reasons, and because the color is also welcoming and appetizing.

In chromatherapy, orange is considered a stimulant for the healing process, increasing immunity, promoting happiness, and enhancing sexual potency. Not surprisingly, it is not recommended for people who are easily agitated.

Historically, orange was used in flags and crests to signify strength, endurance, and success.

GREEN

Mother Nature knows a good thing when she sees it. Green not only represents life and growth, it is also the most relaxing, tranquilizing color in the spectrum.

The reason is physiological. Unlike other hues, green focuses directly on the retina without being refracted, making it especially easy on the eyes. It is also thought to have great healing powers and the ability to soothe and refresh. According to color consultant J. L. Morton's Color Matters website, people who work in green environments have fewer stomachaches.

The paler the green, the more calming it is. That is one of the reasons hospital walls are often painted seafoam, to literally sedate worried patients and visitors. Then there's the use of "green rooms" backstage at theaters and television shows to reduce anxiety prior to performances.

The reassuring quality of green has also made it the official color of safety worldwide, as in "safe to go" traffic signals. Officials in London found another safety use for the color: Painting the ominous Blackfriars Bridge a more soothing green greatly reduced the rate of suicide jumpers.

Greens send a variety of messages, depending on the shade. Kelly greens bring to mind spring and the outdoors, conveying happy, youthful feelings. But that can also suggest immaturity and inexperience, such as a newcomer being "too green" to succeed.

Forest green, on the other hand, is the color of mature trees, representing stability and growth. Not surprisingly, that color is often used in law offices and financial institutions. Remember, green is the color of money, too.

Olive has the most power associated with it because it reminds people of the military, while grass green's connection to new life and growth has come to symbolize fertility. That made it the favorite color for wedding gowns during the Renaissance.

COLOR PSYCH 101

- Pale green is physically the most relaxing and calming color in the spectrum. As the easiest color on the eye, it can improve vision.
- Vibrant greens remind people of the spring, nature, life, and youthful energy.
- Darker greens are associated with stability and growth, suggesting high economic status and success.
- Green is the worldwide symbol for safety. Green also means go.
- People who wear green are thought to be kind, dependable, and generous.

Green has some negative associations as well, such as people being "pea green with envy," as Scarlet O'Hara might say. When someone is seasick, we say they're looking a little "green around the gills." Similarly, chartreuse is consistently rated as the most nauseating of all colors.

In decorating, many shades of green prove harmonious throughout the house. Vivid greens bring the feeling of nature inside and can create a smooth visual flow between the indoors and outside foliage. Those hues also have a refreshing, nurturing quality, making them particularly appealing in kitchens and dining rooms.

Because pale green evokes pleasant feelings of serenity, it is ideal for home sanctuaries, such as bathrooms or peaceful bedrooms. Combining green's peacefulness with the color's subliminal message of antiseptic cleanliness makes it a favorite of spas as well.

In packaging, greens give a sense of purity and freshness, which is why they're so popular on cosmetic containers. Products in green wrappers are also thought to be healthful, natural, and environmentally friendly. And since greens suggest a tart taste, they're often used for bottles of spring water and wine.

BLUE

If blue is your favorite color, you're in good company. Blue is the best liked of all colors. Light- to medium-range blues are especially pleasing and restful. In fact, staring at blue actually reduces your pulse and respiration rate and temporarily lowers your blood pressure.

Practically all our associations with blue are positive. When we see cool or ocean blues, many of us think of the sky and calming waters, or perhaps a vacation on an exotic island.

In many cultures, blue is considered the most protective of all colors. In the Middle East, for example, blue doors are thought to guard against evil spirits, while people in the American Southwest often paint their porch ceilings blue to ward off ghosts.

Before the advent of refrigeration, cobalt blue was used in kitchens and pantries because insects, unlike humans, are repelled by this color. Blue kitchens continue to be popular to this day.

Navy blue in particular represents loyalty and trustworthiness, as evidenced by the expression "true-blue friend." Blue is therefore ideal for expressing sincerity and reliability. When politicians run for office, they often choose navy blue for their suits. After all, what politician doesn't want to be thought of as trustworthy?

Navy blue also commands respect, as with police and military uniforms, while "blue laws" were created to enforce moral standards. Men particularly like blue.

Brighter blues are ideal for wearing to parties and social gatherings if you want all the latest gossip. People will be more inclined to open up to you because blue is so friendly and likable.

Darker blues signify good breeding, high social status, stability, and dignity. The term "blue blood" originated in Spain, where Moorish aristocrats actually believed they had bluer veins than those with mixed ancestry. That was also the thinking in ancient Egypt, where blue varicose veins were considered a sign of royalty and beauty, causing wealthy women to actually paint them on their legs with blue dye. Those were the days.

Blue has been a symbol of fidelity, hope, and faith since ancient times. That's where the tradition of the bride wearing "something blue" originated.

In the home, the deeper blues lend a regal stature and serious atmosphere to a room, while the lighter or brighter blues have more charm and sweetness. In fact, blue is associated with a sweet taste, which is why it is consistently used on sugar packaging and related products. Land O'Lakes butter comes in a yellow box, but the words "sweet cream" are written in blue.

People tend to be more productive in blue rooms, and studies have actually shown that weightlifters can handle heavier weights in a blue gym.

Luxury cars often come in an elegant midnight or silver blue that symbolizes power and success, while sportier cars, such as the Volkswagen Beetle, come in a brighter shade to suggest fun.

PURPLE

Purple could be called the delusions-of-grandeur color. Historically, purple was so difficult and expensive to produce that it could be worn only by society's *crème de la crème*.

According to Simon Garfield's fascinating book *Mauve*, thousands of mollusks needed to be "crushed, salted for three days, and then boiled for ten" just to make enough dye for a single robe.

In ancient Rome, the elusive color was reserved for Caesar, triumphant generals returning from war, and Roman senators. The higher one's rank, the more purple he was allowed to display. Even today, U.S. soldiers who are wounded in combat receive a Purple Heart for their sacrifice.

So it's no wonder that purple is associated with wealth, royalty, and extravagance. But there is a spiritual side as well, since purple later became the color of ecclesiastical robes and the fringe of prayer shawls in Judaism.

Interestingly, the once-exclusive purple is now more popular with women than men. In fact, many women cite purple as their favorite color.

Perhaps purple's color composition has something to do with that, blending, as it does, the excitement of red with the tranquility of blue. It's therefore considered the color of compromise, or striking a happy medium. People who wear purple are thought to be nurturing, passionate, and eager to please—qualities more often ascribed to women than men.

Purple suggests very different emotions depending on its shade. The darkest plum has funereal overtones and can be depressing and solemn. In many countries it replaces black as the official color of mourning.

But plum has an air of mystery and magic as well, giving it an elusive quality that adds to its moneyed appeal. Royal purple, with its noble heritage, also suggests affluence and status, but without the aloofness of darker hues.

Because of the abundance of red in their composition, bright fuchsias carry the most energy. Those are happier, more exciting colors, while violets and lavenders have a romantic, nostalgic quality.

Because of purple's mixed messages, you'll rarely see it in food packaging at the supermarket, or in big-ticket purchases such as cars or appliances. In packages and advertising, the color is most often used to denote products or services aimed at women.

In decorating, purples can be very dramatic and sensual, often adding an old-time Hollywood kind of glamour. But as one top designer said, "Purple is like a spice. In small doses it adds flavor, but too much and it's overpowering."

Since lavender is a delicate, tranquil color, it is often used in bedrooms. Both the color and the scent from the lavandula plant are used homeopathically to encourage sleep.

Creative people, especially artists and designers, are said to love purple. And it's a consistently big hit with children. Little girls can't get enough of it.

COLOR PSYCH 101

- Royal purple exudes class, power, passion, sensuality, and luxury.
- Deep plum is spiritual and mysterious, with a serious, dignified quality. Think "purple mountains' majesty."
- Lavenders and violets have a sweet, romantic, and nostalgic appeal.
- People tend to get less work done in purple rooms because the color encourages daydreaming.
- Women often cite purple as their favorite color.

PINK

Optimists are said to look at the world through "rose-colored glasses." And no wonder, since pink not only promotes affability, but actually discourages aggression and ill will.

Alexander Schauss, director of the American Institute for Biosocial and Medical Research in Tacoma, Washington, studied subjects' reactions to a color he named Baker-Miller pink and found that when used in jails, the color temporarily calmed violent prisoners. In Morton Walker's book *The Power of Color*, Dr. Schauss explained, "Even if a person tries to be angry or aggressive in the presence of pink, he can't. The heart muscles can't race fast enough. It's a tranquilizing color that saps your energy."

Al Capone's cell at Alcatraz was pink.

Staring at pink lessens anger and physical strength so effectively that it has also been used to reduce the suicide rate in correctional institutions and deter antisocial behavior in problem schools. On a lighter note, football coaches have used pink paint in the locker rooms of visiting teams to make their opponents less aggressive on the field.

When you get fired, the notice comes on a "pink slip" to soften the blow. And a Sweet'N Low package is colored pink, implying that the contents will not harm you or later appear on your hips.

In addition to being passive, pink calms and soothes, as in the soothing pink of Pepto-Bismol. That notion goes back to the eighteenth century, when pink was thought to aid in digestion, boosting the popularity of a color called ashes of roses. It must work, since "there's a sucker born every minute" showman P. T. Barnum painted his own mansion's dining room a pale pink.

The slang associated with pink is also upbeat, as in "tickled pink," meaning delighted, and "in the pink," suggesting good health.

While red speaks of passionate love, pink is more nurturing. That's why it is regarded as a feminine color and a perennial favorite for baby girls. People who like pink are often sensitive and romantic.

Shocking pink, as its name implies, is more energetic than the pastel shades because of its high concentration of red. That vibrancy also makes hot pink appear fun and trendy. Studies have shown that the color can be used effectively in children's rooms to discourage overactive

COLOR PSYCH 101

- Pink is the most passive of all colors, promoting affability while discouraging aggression against oneself as well as others.
- Considered the most feminine color, pink is associated with nurturing and compassion.
- Pink calms and soothes, and is thought to aid in digestion.
- Shocking pink has a much higher concentration of red, making it appear energetic, fun, and trendy.
- Men prefer peachy pinks to mauvey ones.

behavior without totally zapping playfulness.

Peachy pinks are often used on the packaging of cosmetics because the color is not only feminine, but also flattering to one's complexion. Mass-market lines such as Maybelline, however, prefer eye-catching hot pinks to grab attention in crowded drugstore displays.

In chromatherapy, a pink room is recommended for people who have trouble calming down and letting things go. No matter how bad your day is, it's hard to hold onto aggression in the presence of pink.

BROWN

Brown literally grounds us. As the color of earth and protective trees, it provides comfort while reminding us of hearth and home.

For that reason, the brown color family becomes especially popular during anxious times of social or economic upheaval. Warm neutrals are perceived as having lasting value and can make people feel like everything is going to be all right.

People who wear brown come across as dependable, sincere, and hardworking. That notion goes back to historic times, when bright colors were reserved for royalty and the wealthy, relegating browns to the peasants. Brown has a common feel and a sense of humility.

If you want to get information from someone in a nonthreatening way, brown is a great wardrobe choice. It will make you look receptive, reliable, and trustworthy, inviting people to let down their guard.

However, brown can lack authority in a conservative work environment. During the cutthroat 1980s, businesslike gray, navy, and black dominated office wear, but were replaced by the more approachable browns in the family-friendly nineties.

In interior design, brown is considered the great leveler, grounding all the other colors. In a lush garden, earthy brown is the perfect backdrop for nature's entire palette, whether warm or cool. And since it is the color of wood, brown is part of practically every room setting.

Muted neutrals are often favorites in living rooms, studies, and family rooms because they radiate simplicity and serenity while creating intimacy. A rich mix of textures keeps the naturals from being boring and can offer a soothing sensuality.

Pale neutrals make a room feel larger and less cluttered, while darker browns create a sense of coziness and security. Chocolate brown walls can be particularly

rich and sophisticated, a trend supposedly started by decorator-to-the-stars David Hicks following an argument with his wife. The story goes that she threw a bottle of Coca-Cola at him and missed, splattering the rich brown liquid on the walls. You can still find house paints named cola brown today.

Men are particularly fond of brown. The color is seen as rugged and outdoorsy, making it ubiquitous in sporting goods, casual clothes, and all-terrain vehicles. The masculine combination of blues and browns is also consistently popular with men in both clothing and home design.

In product packaging, browns say natural. It is unimaginable that Log Cabin syrup might come in a blue bottle. After all, the syrup actually comes from trees.

Paper-bag brown is used to suggest the freshness of food, a reminder of the wrapping used in outdoor produce markets. Along the same lines, some cosmetic companies use recycled paper to create the impression of a natural product without harmful additives.

COLOR PSYCH 101

- Brown is a warm, comforting color associated with the earth, trees, hearth, and home.
- People tend to buy big-ticket products in neutral colors, especially in an uncertain economy. Browns both put consumers at ease and are considered timeless.
- Brown has a common feel in clothing, making one look approachable, reliable, and sincere.
- Brown has a masculine, rugged quality that particularly appeals to men.
- Paper-bag brown is used in packaging to denote a natural product.

GRAY

Gray is the very definition of neutral. It is a color that people rarely love or hate. It doesn't say I'm loyal and trustworthy like navy blue, and it isn't eye-catching and dynamic like red. Gray is noncommittal, formal, and dignified.

Gray also lacks warmth, which can make it appear somewhat remote and solemn. Think of stone churches, graveyards, and skyscrapers.

That freedom from emotional stimulus gives gray an aura of power and wealth. In a man's business wardrobe, for example, a charcoal gray pinstripe suit is the most authoritative choice—so much so that defense attorneys avoid wearing it in the courtroom for fear they will intimidate blue-collar jurors.

The icy coolness of gray makes it popular in office decor as well. As a classy neutral that is neither friendly nor off-putting, gray exudes success and reliability.

Gray is also associated with maturity and wisdom. People with gray hair are thought to have a lifetime of accumulated knowledge and experience.

Advertisers use the term gray market when referring to retirees and their needs. With the baby-boom generation refusing to grow old, this term will take on a very different meaning in the coming years.

In packaging, grays have a rich, prestigious appeal. Luxury automobiles are most popular in silver tones, as are platinum charge cards with their hefty fees. Similarly, high-end boutiques often wrap goods in gray boxes, suggesting that there is a precious gift inside.

Metallic gray, associated with scientific and technological advances, is used effectively when introducing state-of-the-art products. That's another reason the color is a best-seller in top-of-the-line autos, since it hints at engineering marvels lying under the hood.

Then there is silver's connection with speed, a notion constantly reinforced in car commercials. Even the Lone Ranger called out, "Hi-yo, Silver, away!" to his horse when looking for a sudden burst of speed.

In interior design, dark gray is stately and formal, but can be a bit gloomy. While a lighter gray is more restful, neither shade will encourage lively conversation. Grays are better suited to rooms where the occupants are looking for peace of mind.

Interestingly, reactions to the color gray in the home often depend on where a person lives. If the climate tends to be foggy and rainy a good part of the year, gray rooms are considered particularly depressing.

Think twice about grays for the dining room as well, especially darker hues. While they will give the room a period elegance, they create an unappealing backdrop for food.

COLOR PSYCH 101

- Gray represents noninvolvement, giving it a formal, dignified, and conservative authority.
- Unlike neutral brown, gray lacks warmth, which can make it appear remote, solemn, and a bit gloomy when used alone.
- Gray is associated with wisdom and maturity, adding to its moneyed appeal.
- Metallic grays offer the promise of scientific and technological advances, as well as a sense of speed and competence.
- Grays are cool and restful in home decor, but also discourage lively conversation and offer an unattractive backdrop for food.

WHITE

White represents purity, innocence, virtue, and fidelity. No wonder it's the most popular color for wedding dresses.

In clothing, white is often equated with substantial wealth. That notion goes back to the days before the invention of the washing machine, when people who wore white could afford a staff to keep their clothes clean. There's also an implication that its wearer has a high social status, since no one would wear white to perform a menial task.

While many consider white the absence of color, more shades of white are available commercially than of any other color. A visit to your local paint store bears this out.

In fact, Herman Melville spent an entire chapter in *Moby Dick* elaborating on "The Whiteness of the Whale."

White also stands for truth and goodness. A "white knight" rides to the rescue, and a "little white lie" isn't so bad after all. In old movie westerns, the good guys always wear the white hats, while the bad guys wear black.

The ancient Greeks supposedly wore white to bed to encourage pleasant dreams. And because of white's association with heaven and angels, it symbolizes death in India, China, and Japan.

Safety and medical products are often white to suggest antiseptic cleanliness. Think of gauze bandages, cotton balls, and doctors' lab coats.

COLOR PSYCH 101

- White symbolizes purity, innocence, goodness, and truth.
- Even though white is neutral, it is considered a cool color because of its association with snow and ice.
- White is often used to suggest simplicity, sterility, and safety.
- Waving a white flag is the international symbol of a call for a truce.
- White is popular on the packaging of dairy products, low-fat items, and refined ingredients such as sugar and flour.

BLACK

Black is unquestionably the most authoritative and overpowering color. We associate it with death and darkness, resulting in a wary feeling of the unknown. Black can also be mysterious. You can disappear into a black hole, and good luck to you if a black cat crosses your path.

Black's perceived foreboding gives it an air of danger as well, and it is used to great effect for the clothing of bodyguards, bouncers, and FBI personnel to intimidate potential troublemakers. Black is also the most popular color for limousines, Lincoln Town Cars, and the official vehicles that transport dignitaries, because the color implies that the person inside is important and worthy of respect.

Research studies of American football statistics found that teams wearing black uniforms had more disputed plays called against them, apparently because referees subconsciously considered them the aggressors. And why do you think referees' uniforms are dominated by authoritative black?

In the sixteenth century, Anne of Brittany originated the custom of wearing black during a period of mourning. In many countries, widows wear black for the rest of their lives.

In the fashion world, black is truly ubiquitous. The all-purpose "little black dress," first designed by Coco Chanel, comes up again and again as the height of sophistication. (It's also slimming and does not show dirt, two major fashion pluses.)

The words black tie on an invitation underscore the importance of an event, suggesting that formality and elegance will be the order of the day.

COLOR PSYCH 101

- Black, the most authoritative, intimidating color, can appear aggressive when overused.
- Black is considered conservative, serious, and dignified and is used to show respect at solemn and formal occasions.
- In numerous cultures and in heraldry, black is a symbol of grief.
- Black gives the feeling of weight and depth. People think black boxes weigh more than white ones.
- Text is difficult to read against a black background.

Color Trends

The evolution of color trends occurs for one reason: People want change. We all eventually get bored with the status quo and feel like moving on to something new. But what? That's the billion-dollar question.

Color-trend forecasters around the globe are constantly on the lookout for the next big thing. What will consumers want next month, in six months, in six years? Arriving at the answers to these questions is more complicated today than at any other time in our history.

We live in an instantaneous-results culture. The Internet and technological advances in the transmission of information provide immediate access to news of world events. Email and portable cell phones mean we're never out of touch. Consumers have also gotten used to customization. We get what we want when we want it.

That is a far cry from the early, more dictatorial days of trend forecasting, when designers had the upper hand. The fashion industry selected a color palette each season and consumers bought it. After the public grew accustomed to the new shades, the colors would begin to appear in home design and product packaging, where they were readily accepted.

In retrospect, it's amazing how easily the public was manipulated. Following World War II, for example, the United States government was looking for a return to "normalcy," which required women to abandon their wartime factory jobs and go home to raise children. The fashion industry silently colluded by replacing neutral-colored menswear-like suits with hourglass-shaped dresses in feminine pastels. Returning soldiers wanted women to look like women again, and fashion designers happily obliged.

Brilliant marketers could also influence the public's taste in colors. "In 1934," writes Garry Trudeau in *Time* magazine, "the American Tobacco Co. found that women wouldn't buy Lucky Strikes because the then green box clashed with their clothes. The solution: make green hot. In short order, the company set up a 'color-fashion bureau,' underwrote a green-themed society ball, enlisted magazine editors and bought off French couture houses. By year's end hordes of newly sensitized women started buying Lucky Strike packs as fashion accessories."

Though the thought of Philip Morris dictating color trends to the haute couture might seem far-fetched today, there was a reason the French fashion industry was more susceptible in the 1930s. Prior to World War I, Paris had been the *dernier cri* in color-trend pronouncements, along with European fabric mills. But in 1915, concerned about the lack of trans-Atlantic fashion communication during the war,

the Color Association of the United States (CAUS) was founded to coordinate and publicize color palettes for a variety of American industries.

Designers also looked to Hollywood and glamorously dressed stars for their inspiration, usurping Paris's hold as trend arbiter. While Europe regained much influence after the war, the United States never relinquished its role as a player on the world fashion stage.

CAUS continues to provide invaluable color forecasts to this day, but its job is much more complicated than that. A whole network of color-forecasting groups now works to anticipate and predict changing consumer color preferences. The largest of these organizations is the Color Marketing Group (CMG), an international, not-for-profit association of 1,700 color designers. As with most trend-forecasting companies, the CMG consults with style experts in a wide variety of fields to build a consensus on where color trends seem to be headed and why.

When writing about trend predictions, the news media often focus on the so-called Cool Hunters, a group of youthful trend watchers who travel to urban areas around the world, shopping at high-end boutiques and flea markets while documenting street fashion and new design directions.

However valuable this information might be, it must be combined with lifestyle, cultural, political, and economic research to get an accurate picture of future color trends.

For example, what are people doing in their spare time?

In the 1990s, gardening was the number one adult hobby in the United States. Combined with a renewed interest in environmental concerns, this love of the outdoors translated into a green-dominated color palette.

What are the hot restaurants and which country inspires the cuisine? When the Mediterranean diet of fresh produce became popular, the rich, saturated colors of ripe fruits and vegetables affected color trends. Japanese sushi opened the door to black, white, and red, while Tex-Mex brought in warm, sun-baked shades.

Where are people going on vacation? Kitschy neon brights suddenly dominated sportswear after Las Vegas surpassed Orlando as the number one family vacation destination in the United States. In addition to following documented trends in travel, forecasters pay attention to casual conversations with hip friends and acquaintances. When the third person mentions a leisure trip to Thailand, that country's culture appears on the design radar screen.

Popular movies, hot musical groups, and blockbuster art exhibits also have an enormous impact on trends, and forecasters don't look just at the here and now. Hollywood trade publications report on movies in the pipeline and where they are set to be filmed. When three competing motion picture studios are all planning biographies of artist Frida Kahlo, the odds are one of them will make it to the big screen. Count on hot Mexican colors to follow.

Would it surprise you to learn that the most popular tourist destination in New York City is the Metropolitan Museum of Art? Researchers continually scan art publications for the dates of upcoming major exhibits, especially those that will travel to several countries. When hordes of people are suddenly exposed to Degas pastels, Matisse brights, Warhol pop, or Hopper retro darks, acceptance of those color palettes grows. The popularity of metallic fabrics during the disco days of the 1970s is often attributed to the attendance record-breaking King Tut exhibit.

Major political and cultural events also affect color trends. What is the next host city for the Olympic Games? The local people and culture will be scrutinized by the worldwide media and simultaneously broadcast into millions of homes. Likewise, historic anniversaries focus on specific locales, as do major political elections.

There are less tangible factors as well, such as a general zeitgeist or "something in the air." When baby boomers created their own baby boom, this formerly rebellious demographic group returned to religious institutions in record numbers for the sake of their children. Psychologically, the color purple is most

closely associated with spirituality, and it suddenly started popping up on everyone's color charts.

The economy and consumers' buying habits are always important. The general thinking is that the better the economic times, the more "color risk" consumers are willing to take; in periods of uncertainty, in contrast, people gravitate toward time-less neutrals. But there's more to the story.

It is true that the public selects "safer" hues when purchasing big-ticket items in a down economy, but they're also looking for fun, fresh colors to cheer themselves up. So-called "disposable" items—clothes, shoes, handbags, costume jewelry, and decorative accessories for the home—actu-

ally sell better in unorthodox fashion colors that customers don't already own. It's the newness that offers the most appeal.

Since color trends are cyclical, designers also consistently mine past decades for color inspiration. Mayer Rus, who served as an editor for both *Interior Design and House & Garden* magazines, says the best design is never linear. "There's a constant backing and forthing," he explains, "referencing and embracing the past while bringing it into the present and moving it forward." Colors will always come back, but not in the exact same way.

The Information Age has shortened the cycle of color trends. It used to take about five years for trends to pass from

haute to mass market, but instant exposure—such as live runway videos on the Internet —helps colors catch on quicker. For industries with long production lead times, the job continually gets harder.

Just how important is color to the consumer? It's often the deciding factor in many purchases, from a new couch to a new car. Research studies on women's shoe-buying habits found that color was the primary consideration, followed closely by style, with fit a distant third. Color is also cited as the number one reason for impulse purchases, which keep the economy humming even in the worst of times.

After World War II, for example, the automobile industry used color to entice customers back into their showrooms. Not only were the shades bright, but two- and three-tone paint schemes accentuated the exaggerated design details, such as chrome side treatments and elongated fins.

This brings up the issue of using colors "appropriate" for a product's design, target market, and end use. While subscribing to color-trend reports is an invaluable tool, the palettes and resulting color harmonies need to be interpreted wisely for each industry.

Obviously, the first consideration is technical, as color reproduces differently on fabrics, paper, rubber, plastics, and metal. The psychology of color, however, can be equally important, not only in how people initially react to colors on an emotional level, but also in color preferences based on age, gender, geography, and ethnicity.

COLOR AND AGE

Today's teens are growing up bombarded by changing images on the Internet and in video games, so they're not only open to the latest color craze, they actually welcome it. Inspired by musical groups, sports fads, and film stars, this younger generation is constantly on the lookout for the next "must have" fashion trends.

Younger consumers are also more optimistic and adventurous than their parents and are willing to make gutsy color choices on big-ticket purchases such as cars.

Baby boomers, not nearly ready for retirement, pay close attention to trends as well. Like Generation X, they enjoy updating their wardrobes seasonally, but don't consider themselves slaves to fashion. When it comes to home decorating, GenX is a bit more traditional then their younger siblings, while boomers tend to pamper themselves, creating sanctuaries with tones that calm and soothe.

Seniors prefer brighter, cleaner colors, according to the CMG, because the "ability to distinguish hues diminishes with age."

COLOR AND GENDER

If you're in doubt about who makes the color decisions in the majority of households today, just walk into a paint store. There are actually signs in the windows of many mom-and-pop operations that forbid men from buying custom-mixed paint without a written note from their wives.

This reverse sexism has some scientific basis. Barbara Richardson, director of color marketing at ICI Paints has more than thirty-two years' experience in the field of color research. She points out that men don't perceive color the way women do and also have a higher incidence of color blindness.

Therefore, men favor simple, monochromatic color schemes—especially in blues or earth tones—while women like more complicated, multilayered effects.

Fortunately for most relationships, men are generally happy to relinquish household color decisions to the women in their lives. The color of their cars, however, is an entirely different matter.

COLOR AND ETHNICITY

For decades, trend forecasters have assumed that Europeans have the most sophisticated color sense, South Americans and Mexicans lavish color in their lives, and Americans are afraid of color. The first two statements may still be true, but there's no longer a continental divide when it comes to color preferences.

The information superhighway, increased global travel, and a more mobile workforce willing to move cross-country at the drop of a hat keep us all on the same page. Add to that an increase in multicultural diversity—such as the growing Hispanic market in the United States— and you have a population constantly exposed to new ideas as well as revered ancestral traditions.

World travelers often bemoan the fact that most major cities now look alike. After a recent trend-gathering jaunt, design expert Mayer Rus quipped, "London is just like New York today, except with an accent, better cabs, and worse food."

COLOR: RETAIL VERSUS THE CONSUMER

In selecting colors for products or graphic design, there are two end users to keep in mind: the retailer and the consumer.

In a store or magazine advertisement, the challenge is to get noticed. Here color can be used for its psychological impact on the consumer, as well as for creating the desired illusion of size, dimension, and weight. To clinch the sale, designers must also be careful not to obscure directions or necessary purchasing information. Legibility of type is as important as eye-catching graphics.

To complicate matters, consumers will also be picturing the product in their home, wondering if that cooking oil bottle will look nice sitting on their kitchen counter. Removable outer wrappings and specially designed display units can help designers meet both objectives simultaneously.

Process Color Conversion Chart

Color No.	Cyan C	Magenta M	Yellow Y	Black K		Color No.	Cyan C	Magenta M	Yellow Y	Black K
1	0	100	100	45		54	60	0	55	0
2	0	100	100	25		55	45	0	35	0
3	0	100	100	15		56	25	0	20	0
4	0	100	100	0		57	100	0	40	45
5	0	85	70	0		58	100	0	40	25
6	0	65	50	0		59	100	0	40	15
7	0	45	30	0		60	100	0	40	0
8	0	20	10	0		61	80	0	30	0
9	0	90	80	45		62	60	0	25	0
10	0	90	80	25		63	45	0	20	0
11	0	90	80	15		64	25	0	10	0
12	0	90	80	0		65	100	60	0	45
13	0	70	65	0		66	100	60	0	25
14	0	55	50	0		67	100	60	0	15
15	0	40	35	0		68	100	60	0	0
16	0	20	20	0		69	85	50	0	0
17	0	60	100	45		70	65	40	0	0
18	0	60	100	25		71	50	25	0	0
19	0	60	100	15		72	30	15	0	0
20	0	60	100	0		73	100	90	0	45
21	0	50	80	0		74	100	90	0	25
22	0	40	60	0		75	100	90	0	15
23	0	25	40	0		76	100	90	0	0
24	0	15	20	0		77	85	80	0	0
25	0	40	100	45		78	75	65	0	0
26	0	40	100	25		79	60	55	0	0
27	0	40	100	15		80	45	40	0	0
28	0	40	100	0		81	80	100	0	45
29	0	30	80	0		82	80	100	0	25
30	0	25	60	0		83	80	100	0	15
31	0	15	40	0		84	80	100	0	0
32	0	10	20	0		85	65	85	0	0
33	0	0	100	45		86	55	65	0	0
34	0	0	100	25		87	40	50	0	0
35	0	0	100	15		88	25	30	0	0
36	0	0	100	0		89	40	100	0	45
37	0	0	80	0		90	40	100	0	25
38	0	0	60	0		91	40	100	0	15
39	0	0	40	0		92	40	100	0	0
40	0	0	25	0		93	35	80	0	0
41	60	0	100	45		94	25	60	0	0
42	60	0	100	25		95	20	40	0	0
43	60	0	100	15		96	10	20	0	0
44	60	0	100	0		97	0	0	0	10
45	50	0	80	0		98	0	0	0	20
46	35	0	60	0		99	0	0	0	30
47	25	0	40	0		100	0	0	0	35
48	12	0	20	0		101	0	0	0	45
49	100	0	90	45		102	0	0	0	55
50	100	0	90	25		103	0	0	0	65
51	100	0	90	15		104	0	0	0	75
52	100	0	90	0		105	0	0	0	85
53	80	0	75	0		106	0	0	0	100

2

C 0
M 100
Y 100
K 25

1

C 0
M 100
Y 100
K 45

4

C 0
M 100
Y 100
K 0

3

C 0
M 100
Y 100
K 15

6

C 0
M 65
Y 50
K 0

5

C 0
M 85
Y 70
K 0

8

C 0
M 20
Y 10
K 0

7

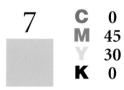

C 0
M 45
Y 30
K 0

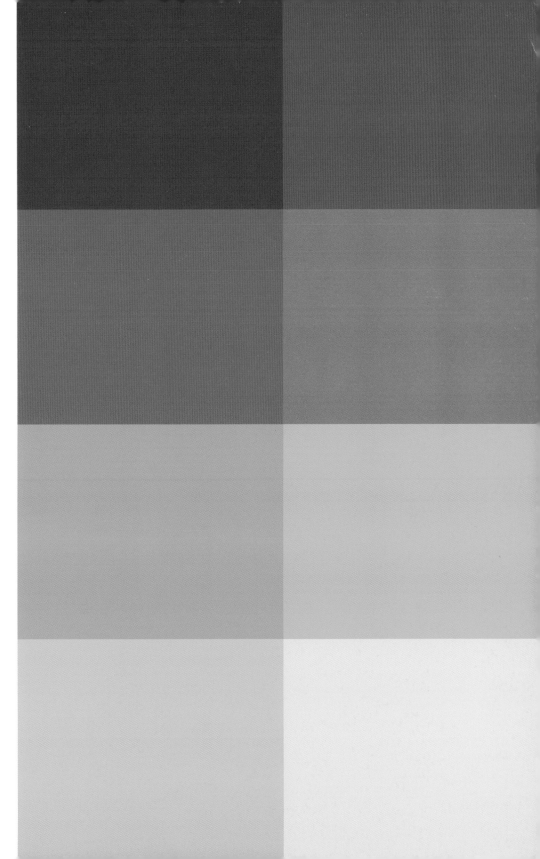

10

C	0
M	90
Y	80
K	25

9

C	0
M	90
Y	80
K	45

12

C	0
M	90
Y	80
K	0

11

C	0
M	90
Y	80
K	15

14

C	0
M	55
Y	50
K	0

13

C	0
M	70
Y	65
K	0

16

C	0
M	20
Y	20
K	0

15

C	0
M	40
Y	35
K	0

18

C 0
M 60
Y 100
K 25

17

C 0
M 60
Y 100
K 45

20

C 0
M 60
Y 100
K 0

19

C 0
M 60
Y 100
K 15

22

C 0
M 40
Y 60
K 0

21

C 0
M 50
Y 80
K 0

24

C 0
M 15
Y 20
K 0

23

C 0
M 25
Y 40
K 0

26 **C** 0
 M 40
 Y 100
 K 25

25 **C** 0
 M 40
 Y 100
 K 45

28 **C** 0
 M 40
 Y 100
 K 0

27 **C** 0
 M 40
 Y 100
 K 15

30 **C** 0
 M 25
 Y 60
 K 0

29 **C** 0
 M 30
 Y 80
 K 0

32 **C** 0
 M 10
 Y 20
 K 0

31 **C** 0
 M 15
 Y 40
 K 0

34

C	0
M	0
Y	100
K	25

33

C	0
M	0
Y	100
K	45

36

C	0
M	0
Y	100
K	0

35

C	0
M	0
Y	100
K	15

38

C	0
M	0
Y	60
K	0

37

C	0
M	0
Y	80
K	0

40

C	0
M	0
Y	25
K	0

39

C	0
M	0
Y	40
K	0

42

C 60
M 0
Y 100
K 25

41

C 60
M 0
Y 100
K 45

44

C 60
M 0
Y 100
K 0

43

C 60
M 0
Y 100
K 15

46

C 35
M 0
Y 60
K 0

45

C 50
M 0
Y 80
K 0

48

C 12
M 0
Y 20
K 0

47

C 25
M 0
Y 40
K 0

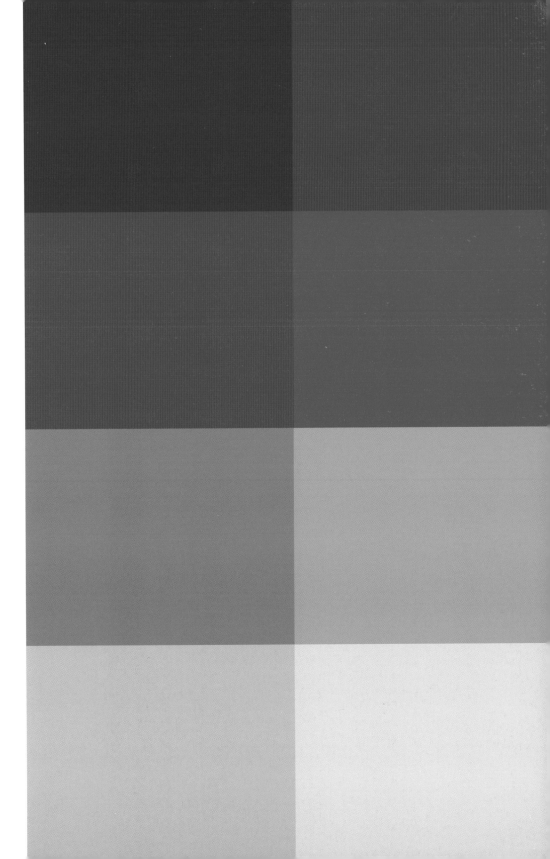

50		C	100
		M	0
		Y	90
		K	25

49		C	100
		M	0
		Y	90
		K	45

52		C	100
		M	0
		Y	90
		K	0

51
C 100
M 0
Y 90
K 15

54
C 60
M 0
Y 55
K 0

53
C 80
M 0
Y 75
K 0

56
C 25
M 0
Y 20
K 0

55
C 45
M 0
Y 35
K 0

58
C 100
M 0
Y 40
K 25

57
C 100
M 0
Y 40
K 45

60
C 100
M 0
Y 40
K 0

59
C 100
M 0
Y 40
K 15

62
C 60
M 0
Y 25
K 0

61
C 80
M 0
Y 30
K 0

64
C 25
M 0
Y 10
K 0

63
C 45
M 0
Y 20
K 0

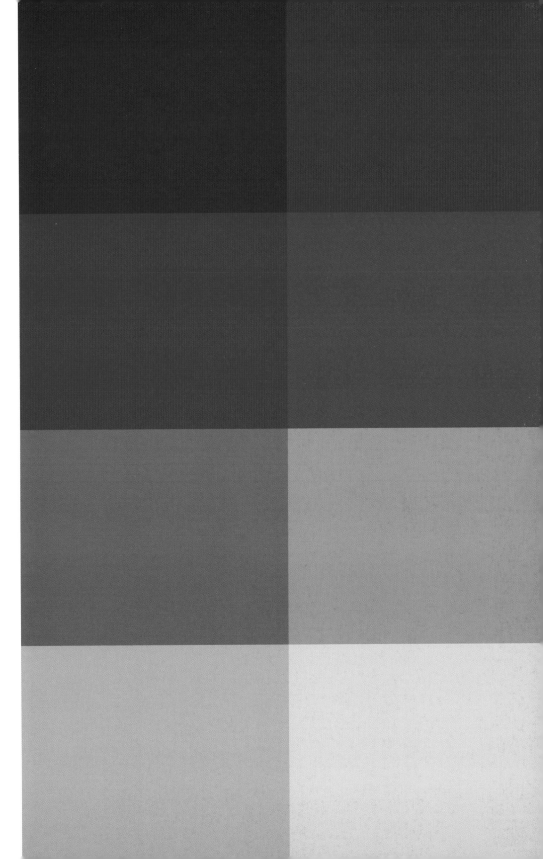

66

C	100
M	60
Y	0
K	25

65

C	100
M	60
Y	0
K	45

68

C	100
M	60
Y	0
K	0

67

C	100
M	60
Y	0
K	15

70

C	65
M	40
Y	0
K	0

69

C	85
M	50
Y	0
K	0

72

C	30
M	15
Y	0
K	0

71

C	50
M	25
Y	0
K	0

74 **C** 100
 M 90
 Y 0
 K 25

73 **C** 100
 M 90
 Y 0
 K 45

76 **C** 100
 M 90
 Y 0
 K 0

75 **C** 100
 M 90
 Y 0
 K 15

78 **C** 75
 M 65
 Y 0
 K 0

77 **C** 85
 M 80
 Y 0
 K 0

80 **C** 45
 M 40
 Y 0
 K 0

79 **C** 60
 M 55
 Y 0
 K 0

82 C 80 M 100 Y 0 K 25

81 C 80 M 100 Y 0 K 45

84 C 80 M 100 Y 0 K 0

83 C 80 M 100 Y 0 K 15

86 C 55 M 65 Y 0 K 0

85 C 65 M 85 Y 0 K 0

88 C 25 M 30 Y 0 K 0

87 C 40 M 50 Y 0 K 0

90
C 40
M 100
Y 0
K 25

89
C 40
M 100
Y 0
K 45

92
C 40
M 100
Y 0
K 0

91
C 40
M 100
Y 0
K 15

94
C 25
M 60
Y 0
K 0

93
C 35
M 80
Y 0
K 0

96
C 10
M 20
Y 0
K 0

95
C 20
M 40
Y 0
K 0

98 C 0
M 0
Y 0
K 20

97 C 0
M 0
Y 0
K 10

100 C 0
M 0
Y 0
K 35

99 C 0
M 0
Y 0
K 30

102 C 0
M 0
Y 0
K 55

101 C 0
M 0
Y 0
K 45

104 C 0
M 0
Y 0
K 75

103 C 0
M 0
Y 0
K 65

About the Authors

Tina Sutton has been a consultant to national corporations, retailers, and advertising agencies for more than 25 years, specializing in color and fashion marketing as well as tracking and forecasting consumer trends. She writes and lectures regularly on these topics, and has appeared on television and radio programs nationwide. She has also served as a columnist and feature writer for the *Boston Herald*, among other newspapers and magazines, writing on style, home design, and lifestyle trends.

Sutton teaches and speaks frequently on "The Psychology of Color" at schools, businesses, and museums, and has delivered lectures at New York's Fashion Institute of Technology, the Massachusetts College of Art, Skinner Auction Galleries, and the Springfield Museums. She researches fashion and color trends through history as well, and recently wrote the catalog for the *Hollywood Costume Exhibit: Dressed for the Part* at the American Textile History Museum.

Bride Whelan is the executive director of the Society of Publication Designers, NYC. For ten years she has taught color theory and practice at Parsons School of Design. Ms. Whelan's work in color has been featured in Conde Nast's *House & Garden* and *Gourmet* magazines. She has appeared frequently on NBC's *Today Show*, CBS *Morning News* and Fox *Television News*, discussing the role of color in everyday living and personal environments. Her expertise in color solutions has led her to work with the leading proponents of the industrial, home furnishings/shelter, and design industries. A new book detailing this wide range of topics is scheduled for publication in Fall 2004.

Photo Credits

© Steve Allen/Brand X Pictures/PictureQuest, 37

© Tony Baker/Brand X Pictures/PictureQuest, 49 (top); 86

© BananaStock/BananaStock, Ltd./PictureQuest, 17; 45 (middle); 82

Bobbie Bush/www.bobbiebush.com, 15

© Burke/Triolo/Brand X Pictures/PictureQuest, 16; 45 (top)

© Ron Chapple/Thinkstock/PictureQuest, 44 (top)

© Philip Coblentz/Brand X Pictures/PictureQuest, 18; 19; 106; 118

© Corbis Images/PictureQuest, 66; 182

The Crafter's Project Book, Rockport Publishers, Artist: Elizabeth Cameron/Kevin Thomas, 43

© Creatas/PictureQuest, 98; 186 (bottom)

Guillaume DeLaubier, 167; 183 (top)

DigitalVision/PictureQuest, 38

A Gardener's Craft Companion, Rockport Publishers, Sandra Salamony, Mary Ellen Driscoll/Bobbie Bush/www.bobbiebush.com, 181 (top)

© Jonathan Fox/Brand X Pictures/PictureQuest, 50, 126

Tria Giovan, 22

Courtesy of Glidden, an ICI Paint Company/www.glidden.com, 20; 23; 24; 25; 26 (middle); 28; 29; 30; 31 (bottom); 36; 42; 45 (bottom); 46; 70; 78; 114; 138; 146; 156; 157; 161; 164; 165; 166; 169; 170; 178; 179 (top); 180; 185; 186 (top)

Reto Guntli, 21

© Mitch Hrdlicka/Photodisc/PictureQuest, 62

Hornick/Rivlin/www.hornickrivlin.com/Cheryl & Jeffrey Katz, Design, 9; 40; 173 (bottom)

Courtesy of IKEA/www.ikea.com, 173 (top)

© Image Source/elektraVision/PictureQuest, 48; 54; 74

Keller & Keller/www.kellerkeller.com, 160; 174; 179 (bottom)

© Tim Krieger/Brand X Pictures/PictureQuest, 58
La Casa Loca, Rockport Publishers, Kathy Cano Murillo/Bobbie Bush/www.bobbiebush.com, 44 (middle); 159

Making Handbags, Rockport Publishers, Ellen Goldstein Lynch, Sarah Mullins, Nicole Malone/Bobbie Bush/www.bobbiebush.com, 90

Courtesy of Marimekko/www.marimekko.com, 150; 168; 183 (bottom)

Courtesy of Mariposa, www.mariposa-gift.com, 35; 41; 176

© Allison Miksch/Brand X Pictures/PictureQuest, 49 (bottom); 94

Courtesy of Mottahedeh, 110

One Color Graphics, Rockport Publishers, Ologi packaging by Turner Duckworth, 175

The Perfect Package, Rockport Publishers, Shower Power packaging by Turner Duckworth, 187

Gabrielle Revere/Kate Sullivan, Design, 44 (bottom)

Eric Roth, 4; 26 (bottom); 27; 130; 155; 163; 171

© RubberBall Productions/PictureQuest, 142

Evan Sklar, 6

© Stockbyte/PictureQuest, 134

Tim Street-Porter, 122

Courtesy of Teign Valley Glass, Newton Abbot, Devon, UK, 39

Brian Vanden Brink, 26 (top)

Courtesy of Volkswagen of America, 184

© David Wasserman/BrandXPictures/PictureQuest, 102

Courtesy of Zimmer + Rohde/www.zimmerrohde.com, manufacturer of fine textiles, 31 (top); 181 (bottom)